People

GONE TOO SOON

CONTENTS

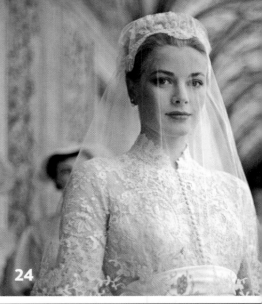

24

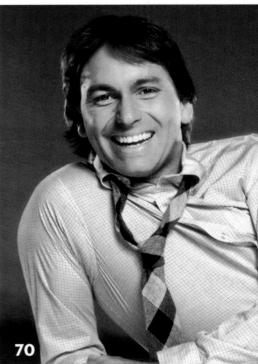

70

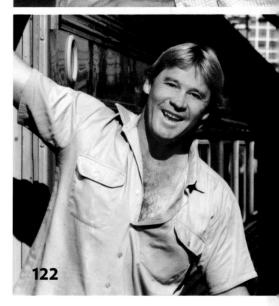

122

42

34

12

92

46

61

74

UNFORGETTABLE

An astonishing fact: When Elvis Presley died in 1977, PEOPLE didn't put him on the cover. Instead, the magazine addressed the King's untimely passing with just one picture, one paragraph and 171 words, in Star Tracks—right above an item about a new Dorothy Hamill ice-skating doll.

Looking back, it seems like a bizarre decision. But we, the editors, meant no disrespect: The magazine was new and still struggling every week to define what it was and learn what readers wanted. Quite simply, we thought that, for a magazine that thrived on the headlong energy of celebrity and popular culture, death was too morbid a subject for the cover. Readers, we feared, would recoil.

We were, of course, unquestionably, stupendously wrong. Readers made that clear in December 1980, when John Lennon was murdered. By then we had realized that, when someone famous died, readers wanted to connect to the story, immediately: They wanted to know what had happened, and to recall moments in a life they'd followed, often for years; many wanted a keepsake. We put John Lennon on the cover; it became, at that time, the best-selling issue PEOPLE had ever published.

Since then, PEOPLE has made a point of covering the passing of famous people, from entertainers to sports stars to politicians. The saddest stories, of course, are those where the person died young, often at the height of a promising career. This book looks back on those stories, starting with six whose sudden deaths made the world stop and catch its breath: Princess Diana; John F. Kennedy Jr.; Michael Jackson; John Lennon; Princess Grace; and Elvis Presley.

John Lennon
1940-1980
A TRIBUTE

People
weekly

DECEMBER 22, 1980 ■ 95¢

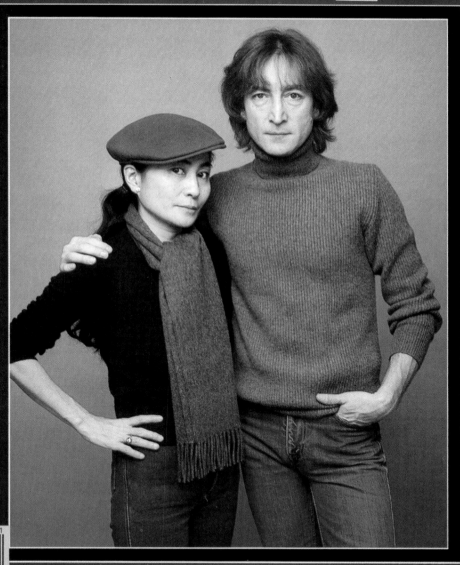

Lennon's death prompted PEOPLE's first tribute cover.

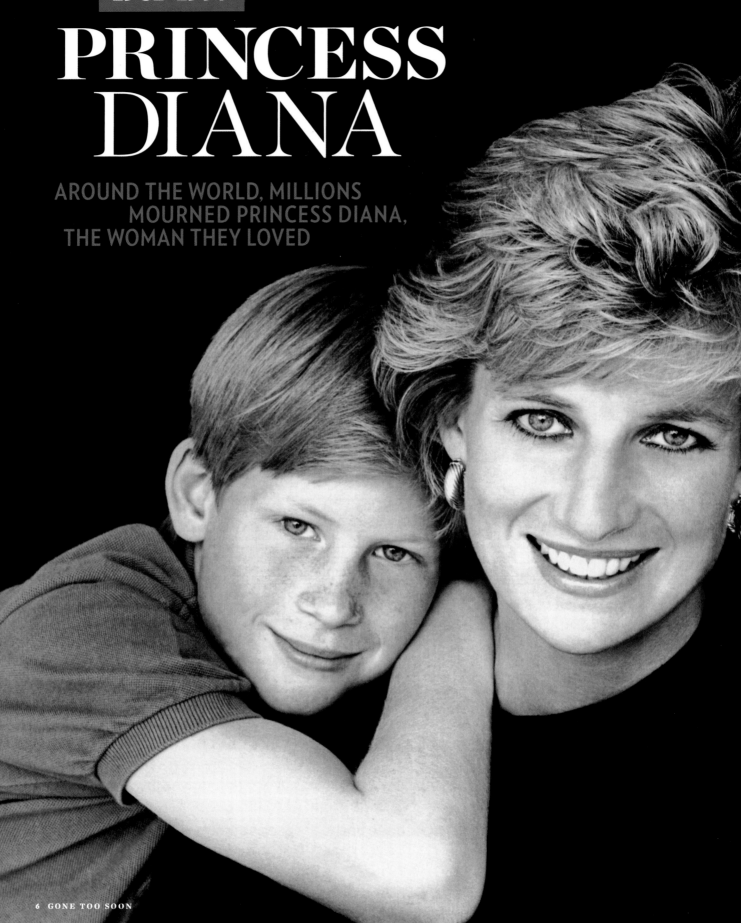

PRINCESS DIANA

AROUND THE WORLD, MILLIONS MOURNED PRINCESS DIANA, THE WOMAN THEY LOVED

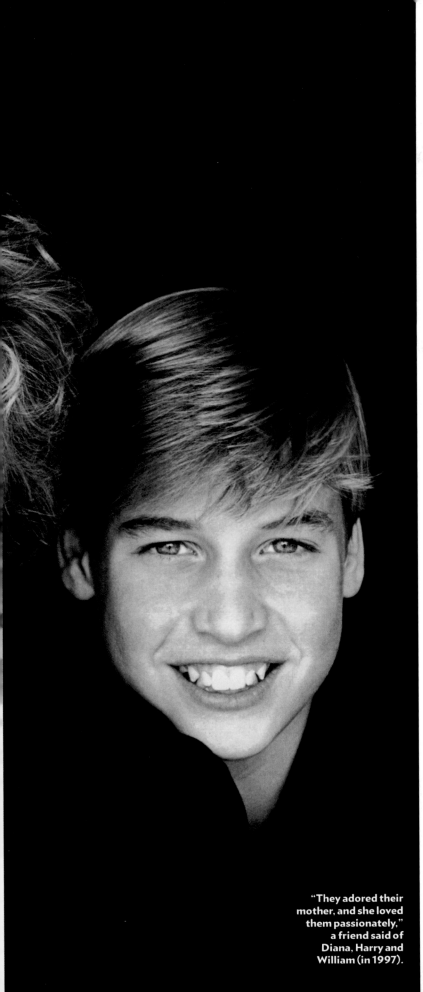

"They adored their mother, and she loved them passionately," a friend said of Diana, Harry and William (in 1997).

Early on the evening of Aug. 30, 1997, Princess Diana telephoned the *Daily Mail*'s Richard Kay, one of the reporters who often wrote about her. She was, he said later, "as happy as I have ever known her. For the first time in years, all was well with her world." After the drawn-out drama of her rocky marriage and headline-making divorce, she had begun a new life and, for the first time, she was publicly dating: In the space of five weeks, she had gone on three vacations with Dodi Al Fayed, 42, son of billionaire Mohamed Al Fayed.

That night, in Paris, Diana and Dodi ate a late dinner at the Ritz Hotel's L'Espadon restaurant. "They looked like two love-struck teenagers," said a Ritz staffer.

At about 11:15, the maître d' whispered that about 30 paparazzi were massed outside the hotel. Minutes later Dodi's Range Rover, with his chauffeur at the wheel, sped away from the hotel—but it was only a decoy, and few of the photographers were fooled. Resigned to running the gauntlet themselves, Diana and Dodi, at about 12:15 a.m., climbed into a Mercedes-Benz S 280 driven by Henri Paul, the hotel's assistant director

of security, and raced from the hotel toward Dodi's apartment, with the paparazzi in hot pursuit. On an expressway along the Seine, Paul picked up speed and entered the Alma tunnel.

Then it happened: "There was this huge, violent, terrifying crash followed by the lone sound of a car horn," said a man who had been near the tunnel entrance.

Racing at an estimated 121 mph, Paul lost control on a slight curve; the Mercedes hurtled head-on into a concrete column, rolled over, hit a wall and came to rest, upright, facing oncoming traffic. Paul, whose blood was later found to contain triple France's legal alcohol limit, and Dodi were dead at the scene; bodyguard Trevor Rees-Jones, the only one wearing a seat belt, was injured but alive. Unconscious, Princess Diana was rushed to a hospital, but doctors could do nothing about her massive internal bleeding. A Palace official announced her death at 4:57 a.m.

Her funeral, five days later in London, drew the largest television audience in history, about 2 billion. The grief-stricken populace piled flowers several feet deep in front of Kensington Palace; thousands of mourners observed the 2-mile march to Westminster Abbey. Many waited through the night in chilly, rainy weather. "One night is nothing after all she gave us," said one Londoner. The funeral

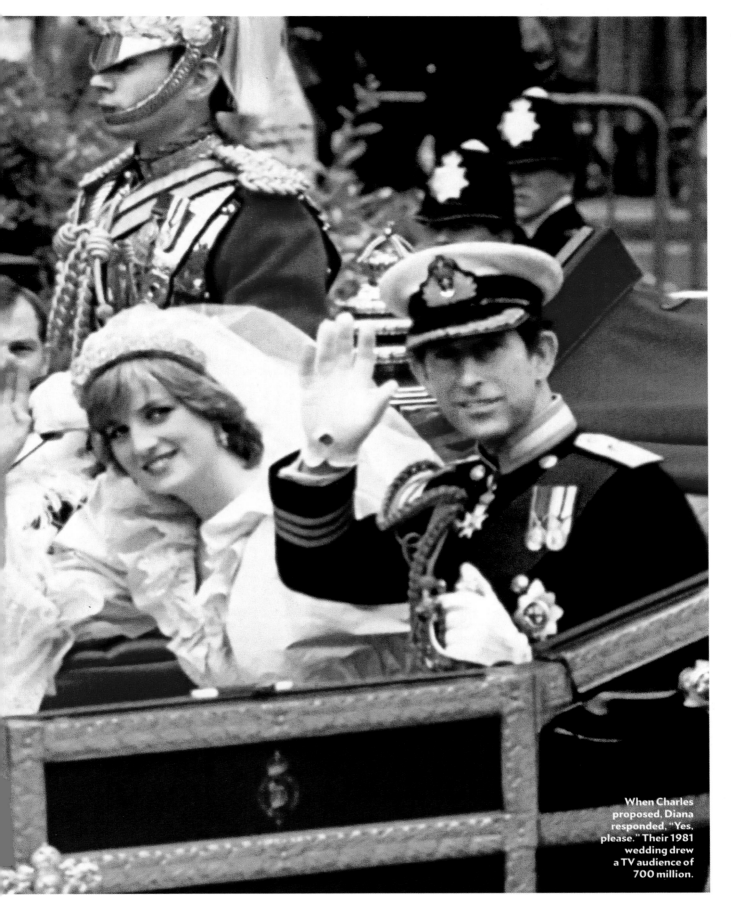

When Charles proposed, Diana responded, "Yes, please." Their 1981 wedding drew a TV audience of 700 million.

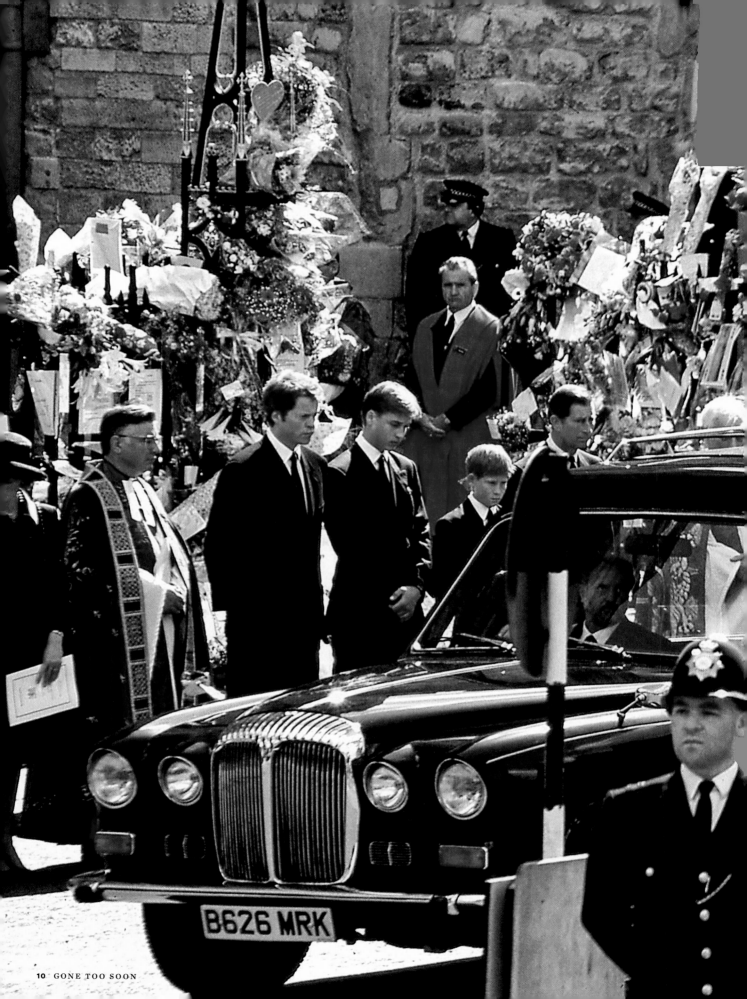

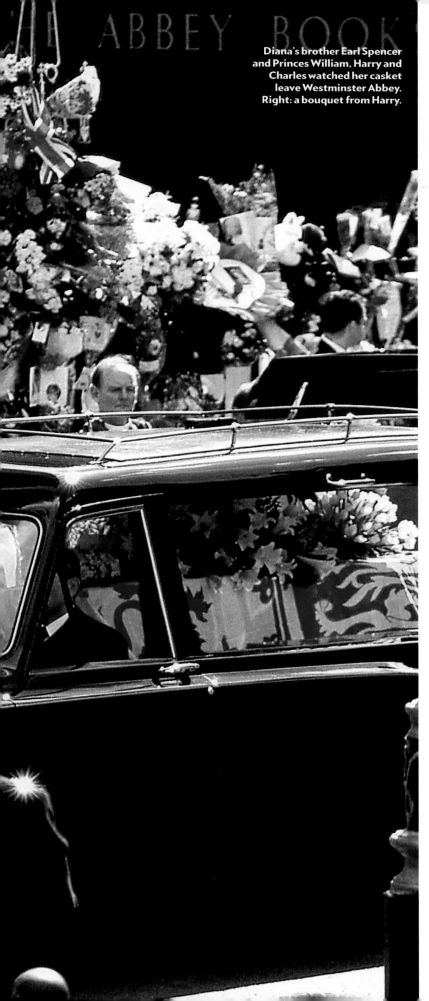

Diana's brother Earl Spencer and Princes William, Harry and Charles watched her casket leave Westminster Abbey. Right: a bouquet from Harry.

procession itself—Diana's flag-draped coffin, on a gun carriage, followed by Princes Charles, William and Harry, members of the royal family and, in a fitting touch, more than 500 workers and beneficiaries from charities Di had helped—was heartbreaking. Said supermarket worker Jason Fryer, 28: "Soon as the first horse come around the corner, the lump in your throat got so big you couldn't possibly have no other emotions."

As the gun carriage passed, the Queen, who stood at the gate of Buckingham Palace, bowed her head—a sensational gesture written in no book of protocol. "It was a lovely gesture," said royals expert Brian Hoey. The royal family "had little love for her, but the Queen was recognizing the affection and respect she was held in by the people."

Diana was laid to rest on a small island on her family's Althorp estate. "Diana was out to make a mark and she did," said a mourner at Kensington Palace. "She conquered the world."

"It's hard for me to talk about a legacy.
We're a family like any other"

1960–1999

JOHN F. KENNEDY JR.

BLESSED AND BURDENED AT BIRTH, HE RESPONDED WITH GRACE AND SELF-DEPRECATING WIT

On a business trip to Toronto five days before his death, John F. Kennedy Jr. was hobbling around on a left ankle broken in a recent paragliding accident. His crutches scarcely slowed him down. Keith Stein, a Toronto businessman who had helped broker a meeting with a potential investor in Kennedy's *George* magazine, marveled at his guest's energy. "He was sticking his head out the car window all the time," said Stein, "curious about everything." When it was time to leave, Kennedy, who had flown in on his private plane from Martha's Vineyard, Mass., with a flight instructor, talked about his love of flying. He lamented that on the trip back to New York he wouldn't have a chance to fly at night, which he especially enjoyed because of the navigation challenges.

Kennedy always exhibited a healthy skepticism about the mythology surrounding his family, yet with his natural passion, daring and style, he effortlessly seemed to embody it. When the single-engine Piper Saratoga II that he was piloting plunged into the ocean off Martha's Vineyard on the night of July 16, 1999, killing Kennedy, 38, his wife, Carolyn Bessette

Kennedy, 33, and her sister Lauren Bessette, 34, it seemed impossible that a life lived so vibrantly could so suddenly end. Across the nation, indeed the world, stricken citizens anxiously monitored the deluge of television, radio and print coverage of the tragedy. On vacation in the Alps, Pope John Paul II sent word he was saying a prayer for the families.

Kennedy had been flying to Martha's Vineyard nearly every weekend that summer, staying with Carolyn at the 375-acre estate he had inherited with his sister Caroline Kennedy Schlossberg after the death of their mother, Jacqueline Kennedy Onassis, in 1994. Around the island John, especially, was a familiar figure, often Rollerblading or riding his bike along the narrow roads or cruising in his beloved vintage Pontiac GTO convertible. Three years earlier he had bought his first aircraft, a two-cylinder ultralight, essentially a seat with a propeller and wings attached, that startled his neighbors. "They didn't know what it was," said one local. "It made this weird noise, like a flying lawn mower. But he really seemed excited about it, because he was always in it."

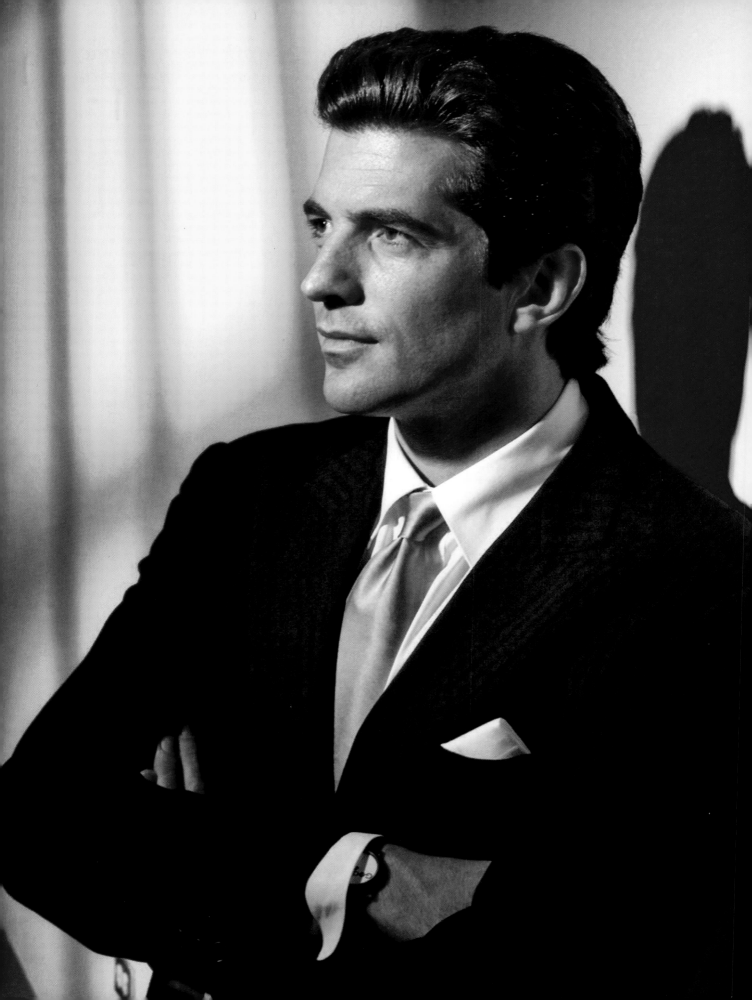

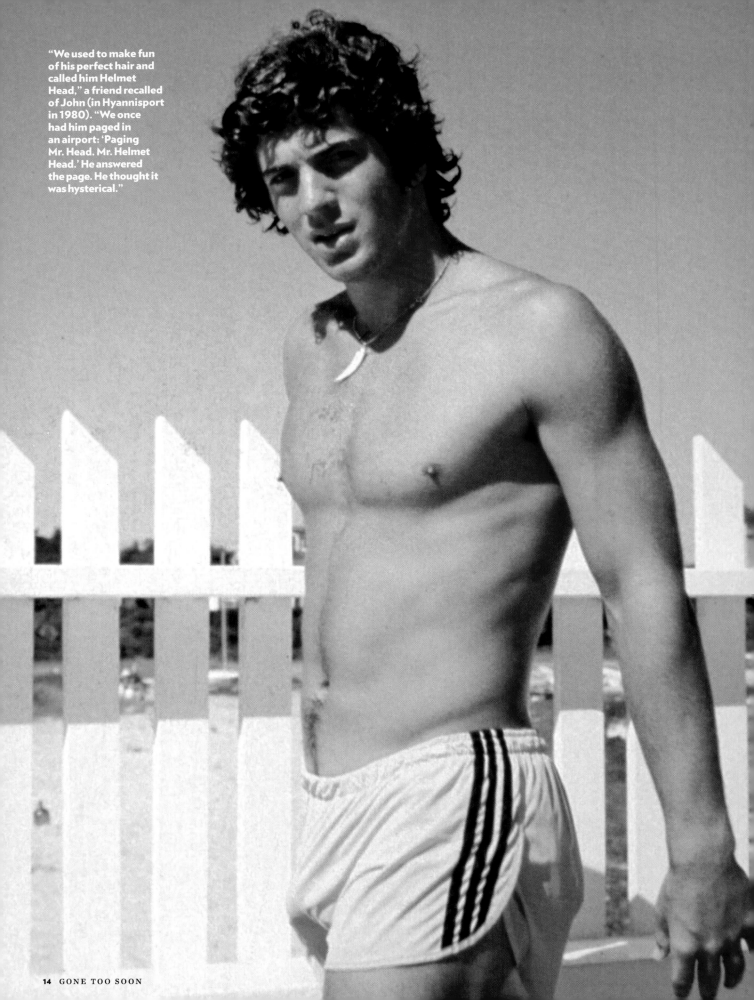

"We used to make fun of his perfect hair and called him Helmet Head," a friend recalled of John (in Hyannisport in 1980). "We once had him paged in an airport: 'Paging Mr. Head. Mr. Helmet Head.' He answered the page. He thought it was hysterical."

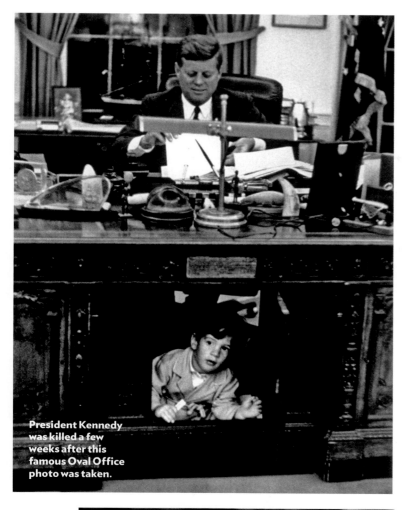

President Kennedy was killed a few weeks after this famous Oval Office photo was taken.

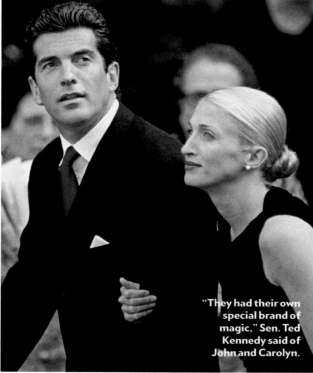

"They had their own special brand of magic," Sen. Ted Kennedy said of John and Carolyn.

His interest only grew. Kennedy went on to get a basic pilot's license, which allowed him to fly in good visibility, and was working toward an instrument rating, which would let him fly at night or in bad weather. He kept his plane, a six-seater he bought used for an estimated $300,000, at New Jersey's Essex County Airport. "He was just one of the guys," said the owner of the local flight school. "He'd hang out like everybody else and talk about flying."

On July 16 Kennedy took off from runway 22 at 8:38 p.m., just after sunset, and headed northeast. At the time, a heat wave had left skies so hazy that one Essex pilot had scrubbed his own plan to fly to the Vineyard. Visibility was somewhere between five and eight miles—within visual flight rules, but hardly ideal conditions. Still, said a charter pilot who knew Kennedy, "he was smart enough to know his limitations."

Kennedy apparently took his usual route to the Vineyard, hugging the Connecticut coastline at 5,500 feet before heading east to cross 30 miles of ocean. He did not contact any of the control towers along the way to get weather updates. At about 9:30 a blip on a radar screen, later determined to be Kennedy's plane, began behaving erratically: descending quickly and turning right, then rising again and turning left. Then it plunged, dropping at nearly eight times the normal rate of descent, and disappeared.

Dr. Bob Arnot, then an NBC medical correspondent, had been flying his own private plane in the area a half hour earlier. At one point, he said later, he hit a wall of haze that obscured everything around him, including the horizon, and he was forced to rely on instruments. "I haven't been in conditions like that for years," said Arnot. I have 5,000 hours, and I had a problem. At 100 hours of flying [experience], I would have been very worried."

The National Transportation Safety Board later determined that, in fading light and with the horizon disappearing, Kennedy had become disoriented and lost control.

"John and Carolyn are true soulmates," said her father, mother and stepfather in a joint statement. ". . . We take solace in the thought that they will comfort Lauren for eternity." In 2001 Carolyn and Lauren's mother, Ann Freeman, reached a financial settlement with John's estate; details were kept confidential.

1958–2009

MICHEAL JACKSON

A SINGULAR TALENT, AND A LIFE LIKE NO OTHER

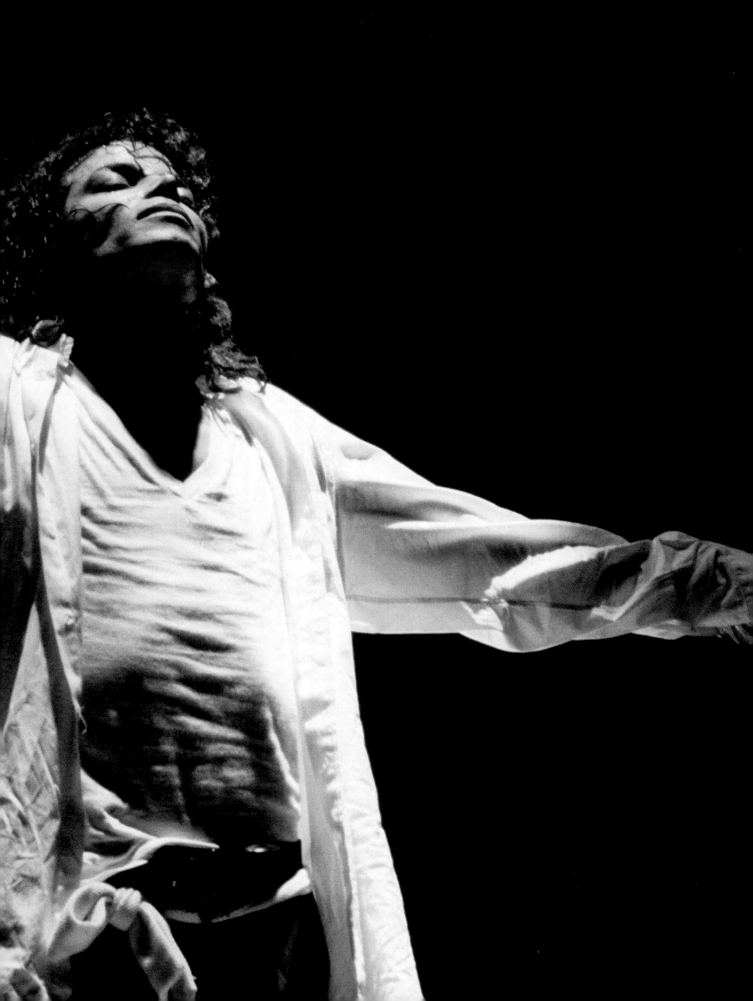

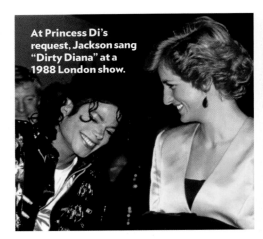

At Princess Di's request, Jackson sang "Dirty Diana" at a 1988 London show.

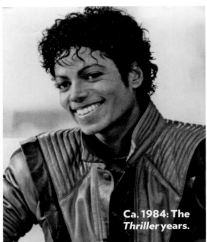

Ca. 1984: The *Thriller* years.

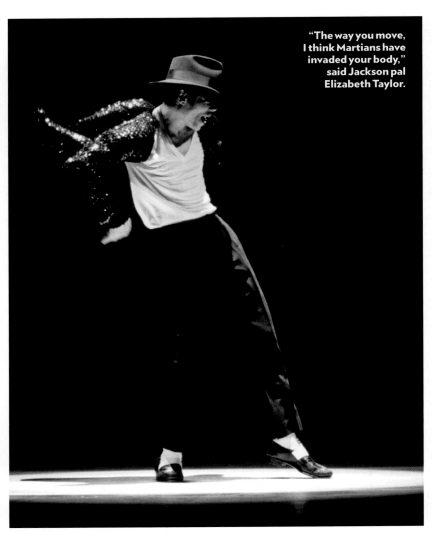

"The way you move, I think Martians have invaded your body," said Jackson pal Elizabeth Taylor.

The Jacksons were a quintet, but there was no question who was the star. Great beats made fans want to dance; lyrics like "Sit down, girl! I think I love you! No! Get up, girl! Show me what you can do!" (from "ABC") made them smile.

Sequined gloves, plastic surgery, Neverland, scandal, marriage (to Elvis's daughter, no less), kids, veils and Bubbles the Chimp. In the longest run, none of that may matter. "There will be a lot written about what came next in Michael's life, but to me all of that is just noise," said Jackson's friend and collaborator, *Thriller* producer Quincy Jones. "I promise you, in 50, 75, 100 years, what will be remembered is the music. It's no accident that no matter where I go in the world, in every club and karaoke bar, like clockwork, you hear 'Billie Jean,' 'Beat It,' 'Wanna Be Startin' Somthing,' 'Rock with You' and 'Thriller.' "

The world agreed: Jackson's sudden death, at 50, caused millions to mourn his loss and celebrate—often spontaneously, in public gatherings from Paris to Shanghai and Buenos Aires—the gifts that made him music's most global phenomenon. Radio stations played his greatest hits nonstop for days, fans staged mass Moonwalks, and celebrities strained to pay tribute to a man-boy who redefined the meaning of superstar. "It goes without saying, the world has lost a true musical icon," said

Usher, "a man who set the bar for artists to focus on a cause bigger than themselves. I'll miss the magic that is Michael." Said Celine Dion: "It feels like when Kennedy died, when Elvis died. It's an amazing loss."

Still, despite a tsunami of love and a televised memorial broadcast worldwide, Jackson, even in death, was touched by scandal. An autopsy revealed his body contained a pharmacy of drugs, including the anesthetic Propofol and three powerful sedatives. The L.A. coroner ruled the death a homicide; in 2011, Jackson's former physician, Conrad Murray, was convicted of involuntary manslaughter and sentenced to four years in prison.

Jackson being Jackson, he was laid to rest as befitted the King of Pop, and as he probably would have wanted. "He was dressed in all white pearl beads, going across, draped across," his sister LaToya told Barbara Walters. "A beautiful big gold belt. Like . . . a belt that you win being a boxer. Full makeup . . . His hair was done beautifully." He looked, said his sister, "absolutely fabulous."

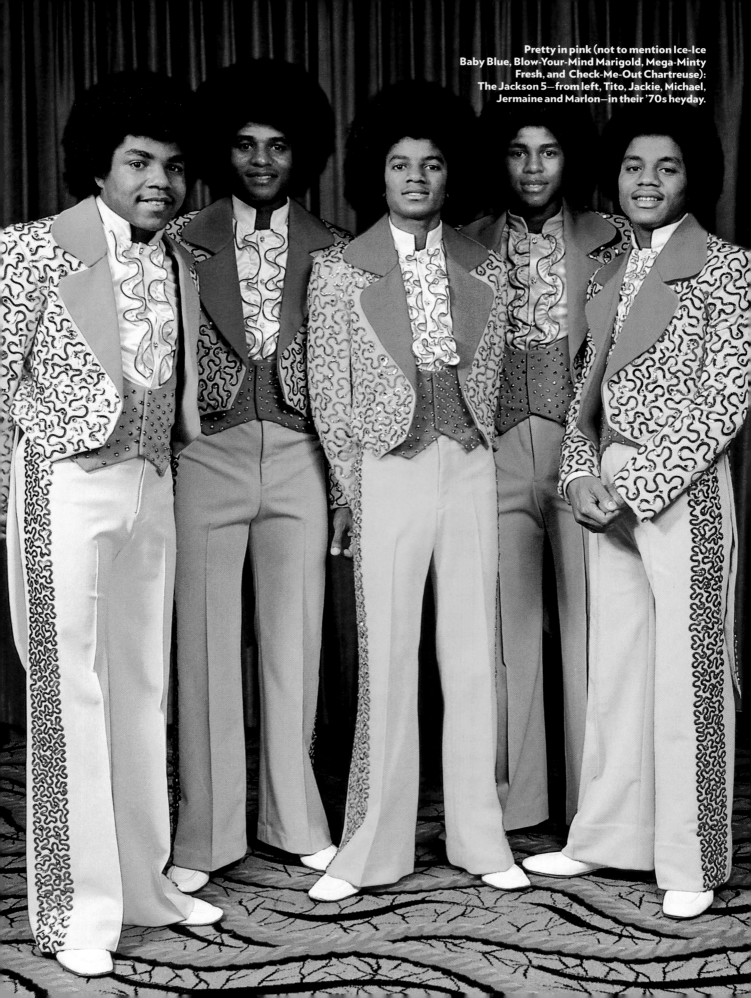

Pretty in pink (not to mention Ice-Ice Baby Blue, Blow-Your-Mind Marigold, Mega-Minty Fresh, and Check-Me-Out Chartreuse): The Jackson 5—from left, Tito, Jackie, Michael, Jermaine and Marlon—in their '70s heyday.

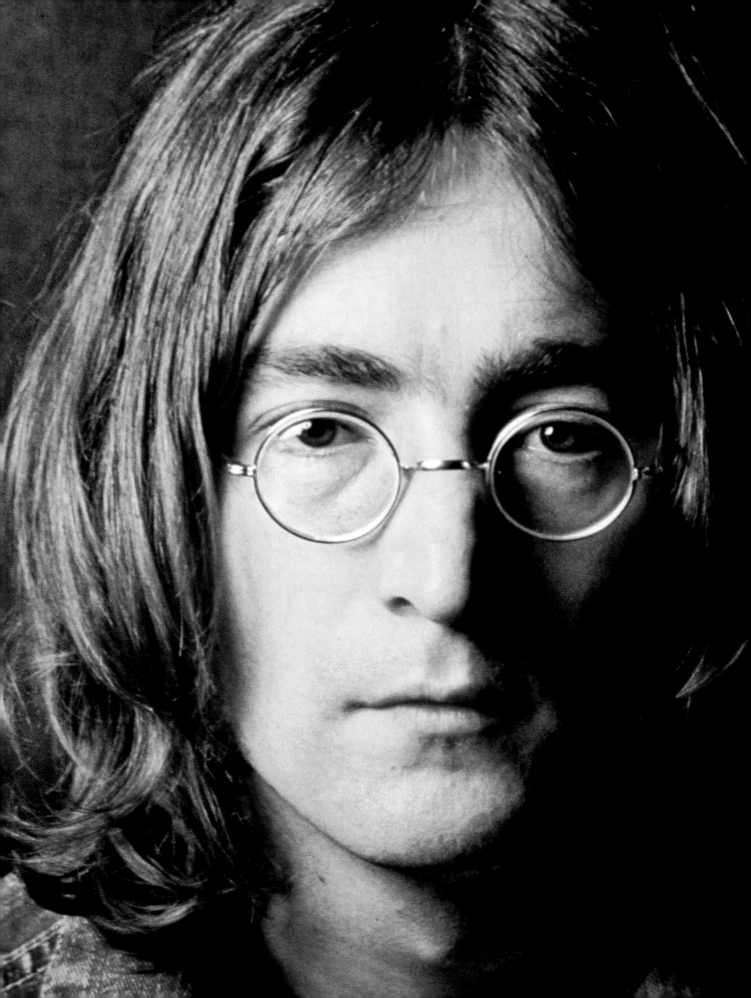

JOHN LENNON

THE MURDER OF AN EX-BEATLE SHOCKED THE WORLD

John Lennon took risks, in music and life. That sense of adventure helped make the Beatles the biggest pop group of all time and his ongoing personal story a headline writer's dream. In 1975 he did it again, something truly revolutionary: Lennon walked away from stardom in an attempt to lead a normal life. He handed his business interests over to his wife, Yoko Ono, and, in their rambling home in New York City's Dakota apartments, became a full-time stay-at-home-dad to his son Sean. He discovered he loved it. "Sean is my biggest pride, you see," he said. "And you're talking to a guy who was not interested in children at all before—they were just sort of things that were around, you know?" He also loved the pace, living a comparatively normal life in a comparatively normal neighborhood. "I can go out right now and go into a restaurant," he told a BBC interviewer on Dec. 6, 1980. "People will come up and ask for autographs, but they don't bug you."

Two days later, as he entered the Dakota on the night of Dec. 8, Lennon, 40, was shot and killed by Mark David Chapman. Holding a copy of

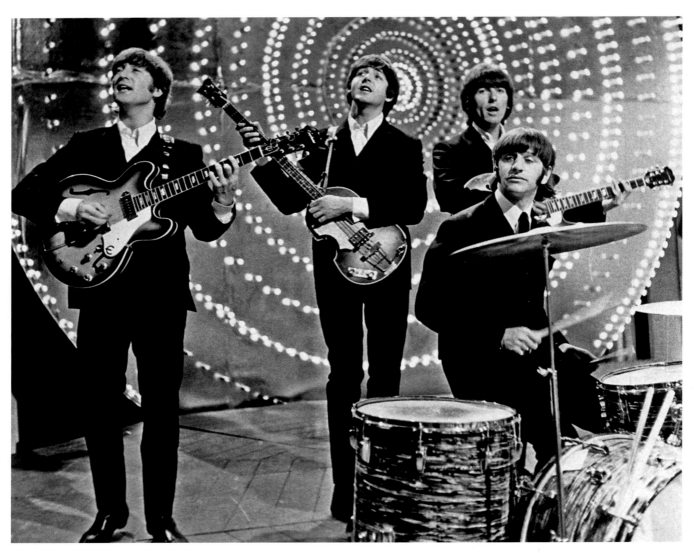

Twist and shout: John, Paul, George and Ringo during the early, classic mop-top era.

The Catcher in the Rye, Chapman waited calmly for police. A troubled young man who had drifted through a series of low-paying jobs and had twice attempted suicide, Chapman later told *The New York Times* that the book would explain his motives. At his arraignment he originally pleaded not guilty by reason of insanity but later decided to plead guilty to second-degree murder. He was sentenced to 20 years to life; now residing in New York's Wende Correctional Facility, he has been denied parole seven times.

On the afternoon of the murder, Chapman, waiting outside the Dakota, saw Lennon leaving and asked him to autograph a copy of the ex-Beatle's *Double Fantasy* album. Lennon obliged. At that point Chapman, who told police he battled "the Devil" in himself, had second thoughts. "My big part won, and I wanted to go back to my hotel, but I couldn't," he said later. "I waited until he came back."

Lennon and Yoko returned around 10:50 p.m. As they entered the building, Chapman fired several shots, hitting Lennon four times.

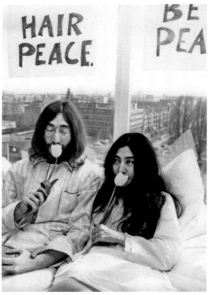

To promote peace, John and Yoko stayed in bed for a week in 1969 and gave interviews to reporters.

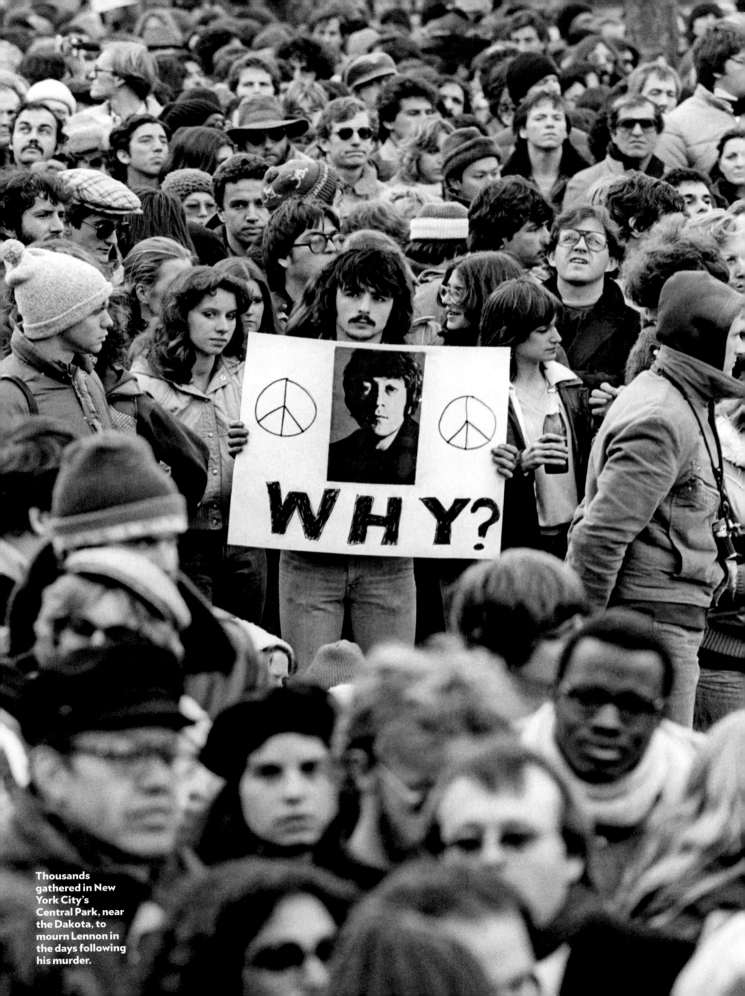

Thousands gathered in New York City's Central Park, near the Dakota, to mourn Lennon in the days following his murder.

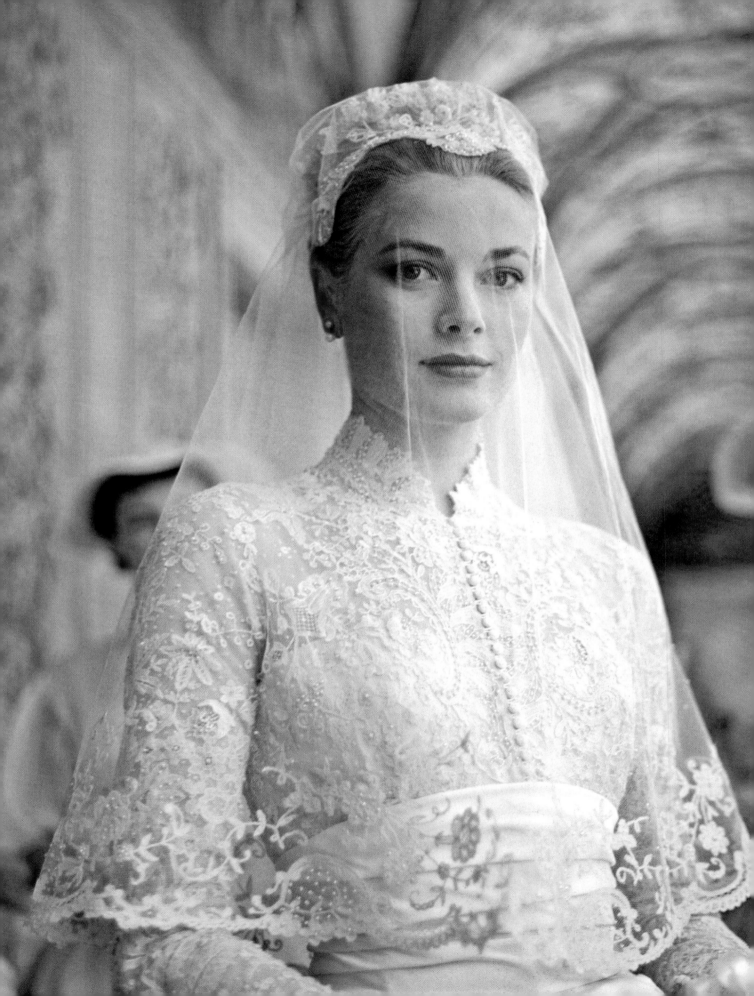

PRINCESS GRACE

AN ACTRESS WHO BECAME ROYALTY, SHE WAS, SAID ONE FRIEND, "A PRINCESS FROM THE MOMENT SHE WAS BORN"

Evading police, she raced her blue convertible through the tight curves above Monaco; Cary Grant sat in the passenger seat, looking queasy. Finally, she parked the car at a turn-off and produced a cold-chicken picnic lunch. "A leg or a breast?" she asked naughtily. "You make the choice," he replied, with a faint smile.

That sort of moment, in the film *To Catch a Thief,* captured Grace Kelly's immense appeal: an elegant, patrician glamour wrapped around a sly sensuality. Her first role, as Gary Cooper's wife in 1952's *High Noon,* made her a star; the next five years produced memorable movies— including *Rear Window, Dial M for Murder* and *The Country Girl,* for which she won an Oscar— and a list of leading men that read like a fantasy Hollywood stag party: Grant, James Stewart, Clark Gable, Bing Crosby, Frank Sinatra. Then,

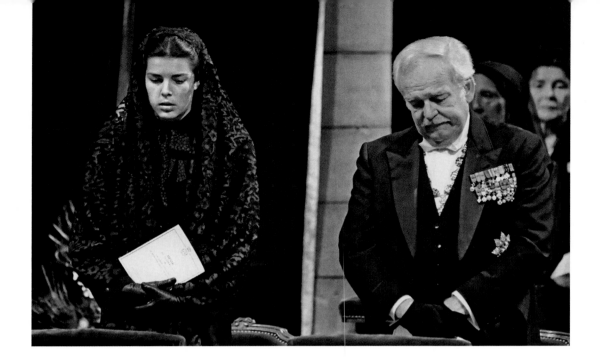

Rainier (with daughter Caroline) wept at the funeral.

after only 11 films and at the height of her career, Kelly walked away.

Actually, she was swept away. While filming *Thief* she had met Monaco's Prince Rainier III; they wed, with all the pomp and circumstance a glitzy principality could muster, in 1956. (However, she did warn him, later, that the Kellys of Philadelphia, of proud Irish-Catholic descent, were "not impressed by royalty. We're impressed by the man. Marriage is not a game of musical chairs with us. We play for keeps.") She moved into Rainier's 180-room pink palace, had three children and, through public appearances and charity work, conferred modernity and glamour upon a 467-acre ministate and gambling mecca that had once been famously described, by Somerset Maugham, as "a sunny place for shady people."

Twenty-seven years after filming *To Catch a Thief*, Princess Grace was driving on the same hillside roads when—doctors determined later—she suffered a small stroke and failed to negotiate a steep turn. The car tumbled 120 feet into a garden and burst into flames. Grace's daughter Stephanie, then 17, survived with a cracked vertebra; rushed to a hospital, Grace died the next day from a brain hemorrhage.

Rainier, who seldom let the world see his emotions, wept openly at her funeral. Said a friend: "He is an old man today."

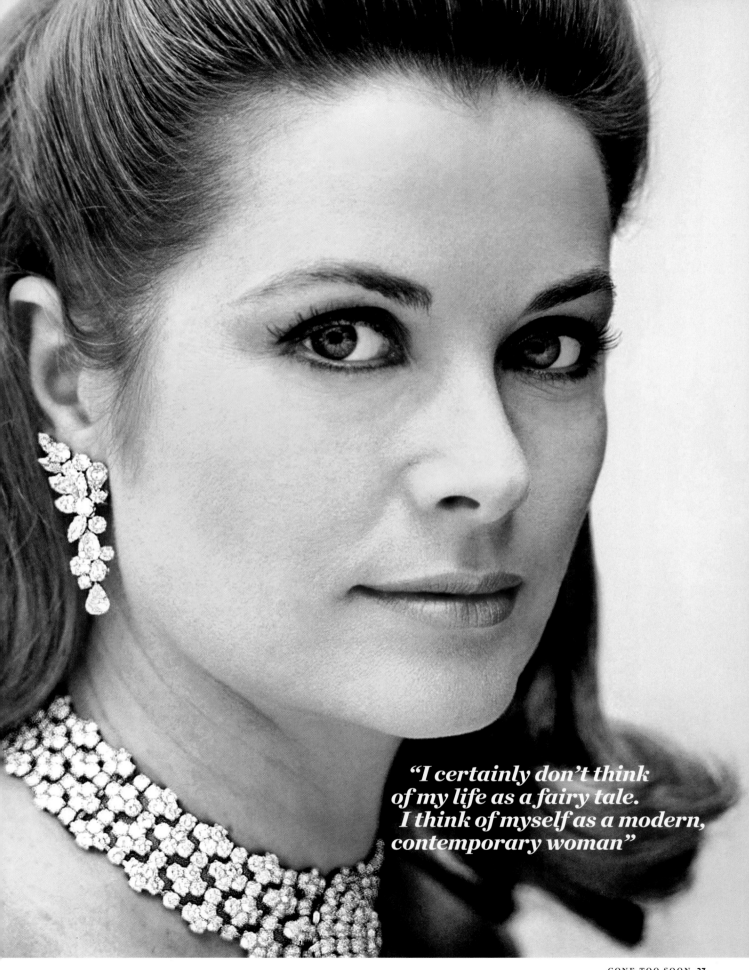

"I certainly don't think of my life as a fairy tale. I think of myself as a modern, contemporary woman"

1935–1977

ELVIS PRESLEY

FAREWELL TO THE KING

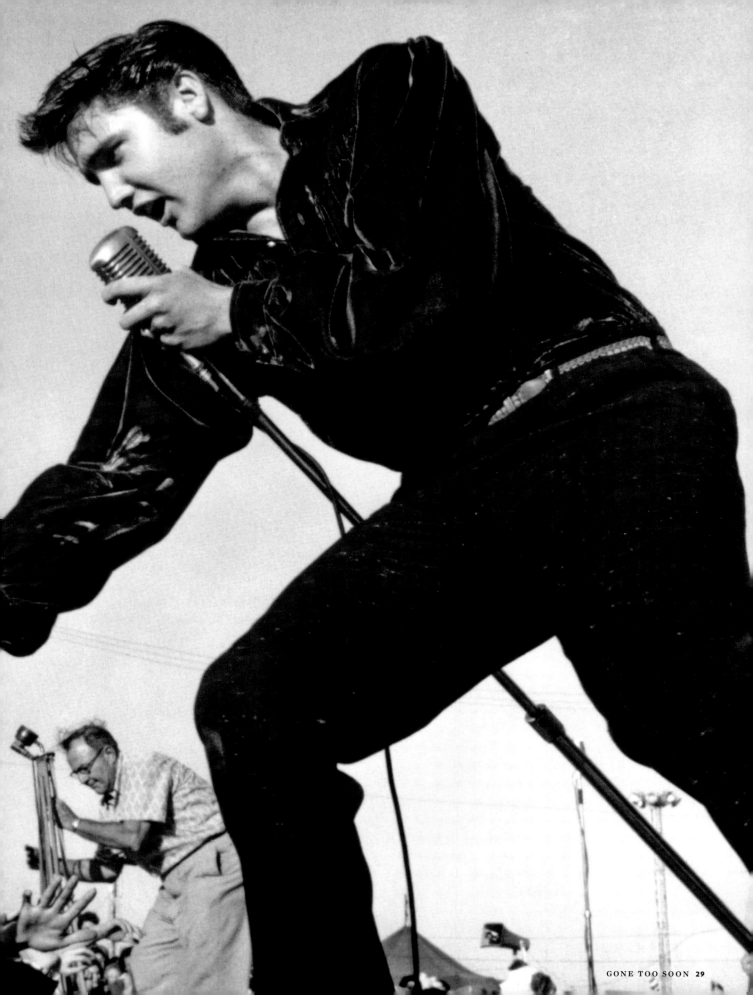

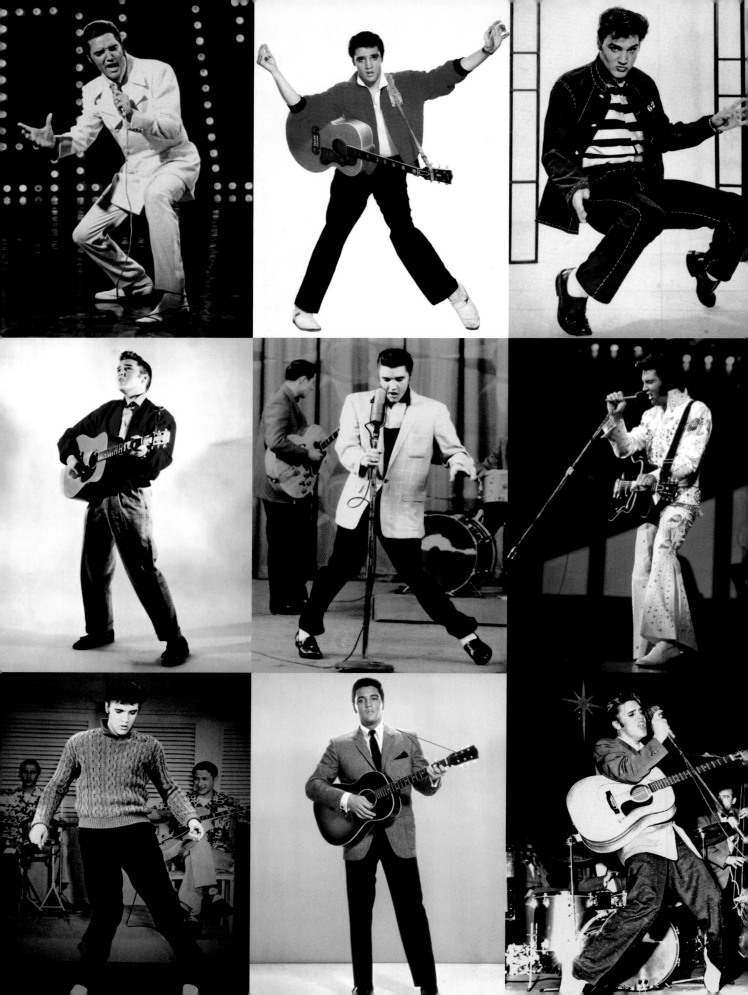

According to one story, it all started because Elvis was so nervous during his first live performances that his knees shook. Girls started screaming, so he incorporated the twitchiness, augmented by a few gyrations, into his act. The forces of righteousness were duly outraged about this discombobulatingly risqué business: Ed Sullivan, during one Elvis appearance, showed the King only from the waist up and, after a Florida judge ordered him to keep his show clean, Elvis reigned in his wandering pelvis—but, he later joked, nonetheless waggled his little finger to the tune of "Hound Dog" like a mischievous madman. "Momma," he once asked, shortly after embarking on a career that would see him sell more than 500 million records and star in 33 movies, "do you think I'm vulgar on the stage?"

"You're not vulgar," his beloved mother, Gladys, replied. "But you're puttin' too much into your singin'. Keep that up, you won't live to be 30."

In the end, it wasn't the singing, but everything else, that killed him. His wily manager, Col. Tom Parker, who banked a reported 50 percent of Elvis's earnings, milked him like a cash cow, keeping him on a relentless concert schedule (nearly 1,100 shows from 1969 to 1977) and signing him up for quickie movies that often made the rockabilly god look like dancing Velveeta. (Elvis never toured outside the U.S. because, it was later discovered, Parker was an illegal immigrant from Holland, and any trip requiring a passport would have revealed his secret.) Elvis's loyal retainers, aka the Memphis Mafia, spent his money, laughed at his jokes and never said no. Nor, for that matter, did his personal physician, Dr. George Nichopoulos, who was more than willing to treat the singer's ailments, physical or spiritual, with whatever modern pharmacopoeia could provide: *The New York Times* reported that, during the 32-month period before Elvis died in 1977, "Dr. Nick" prescribed 19,000 doses of narcotics, sedatives and stimulants for the King.

Elvis died alone in his bathroom at 42. Traces of at least 10 drugs were found in his blood. Said Linda Thompson, his last long-term girlfriend: "He was like a little child who needed more care than anyone I ever met."

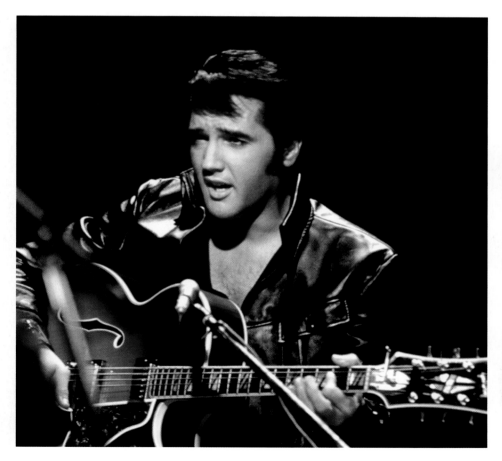

Classic Elvis albums include his first, *Elvis Presley*, and *Blue Hawaii* (below). The King has had more gold and platinum singles than any solo artist in history.

ENTERTAINERS

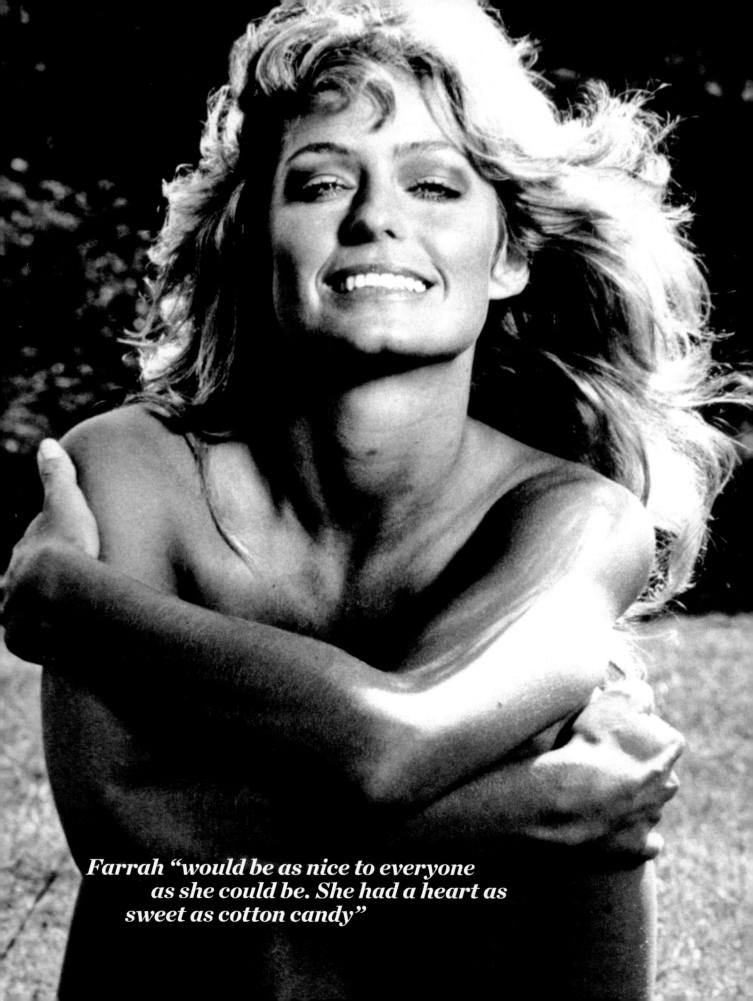

Farrah "would be as nice to everyone as she could be. She had a heart as sweet as cotton candy"

FARRAH FAWCETT

A LIFE SHAPED, FOREVER, BY SUDDEN STARDOM

For 2¹/₂ years, she fought cancer with everything she had. But Farrah Fawcett's final hours were peaceful ones. At her side in a Santa Monica hospital room, her longtime love Ryan O'Neal caressed her and recounted fond memories. "He talked to her continuously through the night," said Fawcett's doctor Lawrence Piro. "He professed his love to her, reviewed their relationship, told stories." Conscious until nearly the end, Fawcett, "lit up when she heard those things."

Fawcett, 62, died on June 25, 2009. Like everything else in the TV icon's life, her illness became a public event, with paparazzi in pursuit and Fawcett herself recording her treatment for an NBC documentary, *Farrah's Story*.

But if anyone understood the bizarre experience of fame, it was Fawcett, who found overnight—literally—superstardom with the 1976 premiere of *Charlie's Angels*.

With her tanned, toned, California look, she was, her manager said, "the female Robert Redford." In that brief moment, the shock wave of her fame was palpable; 12 million people—many of them teenage boys—bought her poster (still a record decades later). Even stepping out for dinner created a sensation. "We would go to Mr. Chow and a riot would break out over her in the streets," said her friend Joan Dangerfield. "They'd have to call police. And she would be as nice to everyone as she could be. She had a heart as sweet as cotton candy."

Even while battling cancer, Farrah found the strength to be kind, and optimistic. Said O'Neal: "She lost her hair. She lost weight. She just hadn't lost hope."

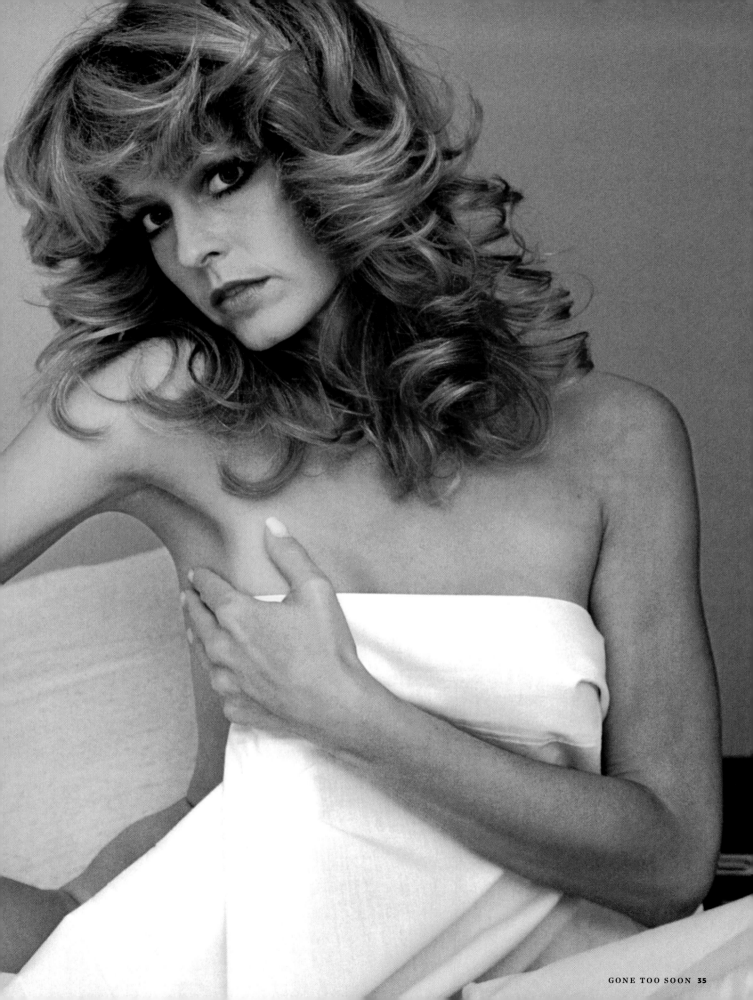

PATRICK SWAYZE

THE MOVIE STAR FACED LIFE, AND DEATH, WITH COWBOY GRIT AND A DANCER'S GRACE

No matter what he was going through, Patrick Swayze never missed a chance to pay tribute to his wife of 34 years. So when Lisa Niemi turned 53 in May 2008, the actor hosted a barbecue for friends and family at his ranch in the San Gabriel mountains near L.A. Although he was battling pancreatic cancer, he remained as determined as ever. "His energy was, 'I'm going to beat this,'" recalled a friend, Bill Rotko. Yet, at the barbecue, "it was the first time you saw Patrick as you think of cancer patients," said Rotko. "He had switched from one chemo to another; it was a type of chemo he lost his hair with, and the fight was more obvious. If you judged a book by it's cover . . . but you couldn't do that with Patrick Swayze because his energy was the opposite. He was a strong guy."

On Sept. 14, after a 20-month battle, Swayze, 57, died at home with Lisa by his side. A classically trained ballet dancer who became a movie leading man, "Patrick was a rare and beautiful combination of raw masculinity and amazing grace," said his *Dirty Dancing* costar Jennifer Grey. A high school football player who could pull off gravity-defying jetés, a big-screen heartthrob who drove his own cattle, Swayze brought his almost paradoxical talents to huge hits like 1987's *Dancing* and 1990's *Ghost*. "He lived 100 lifetimes in one," said Rob Lowe, who costarred with him in 1983's *The Outsiders*. Adds choreographer Kenny Ortega: "He had such an enthusiasm for everything he did. If he could climb it, he climbed it. If he could write it, he wrote it. If he could dance it . . . well, we all know he did. He lived."

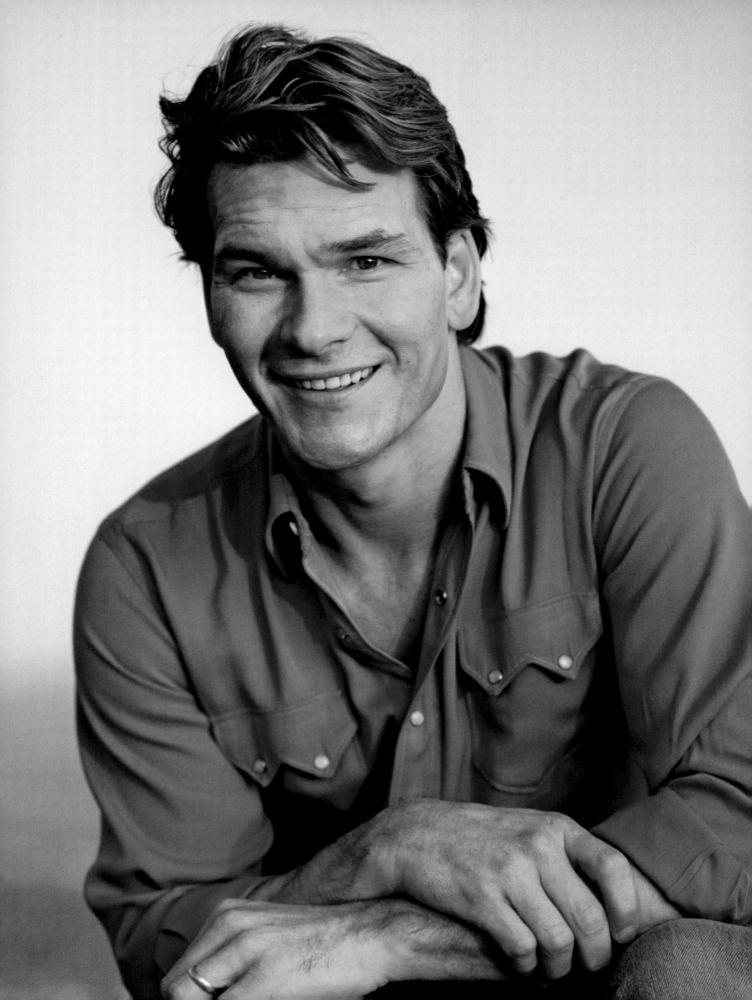

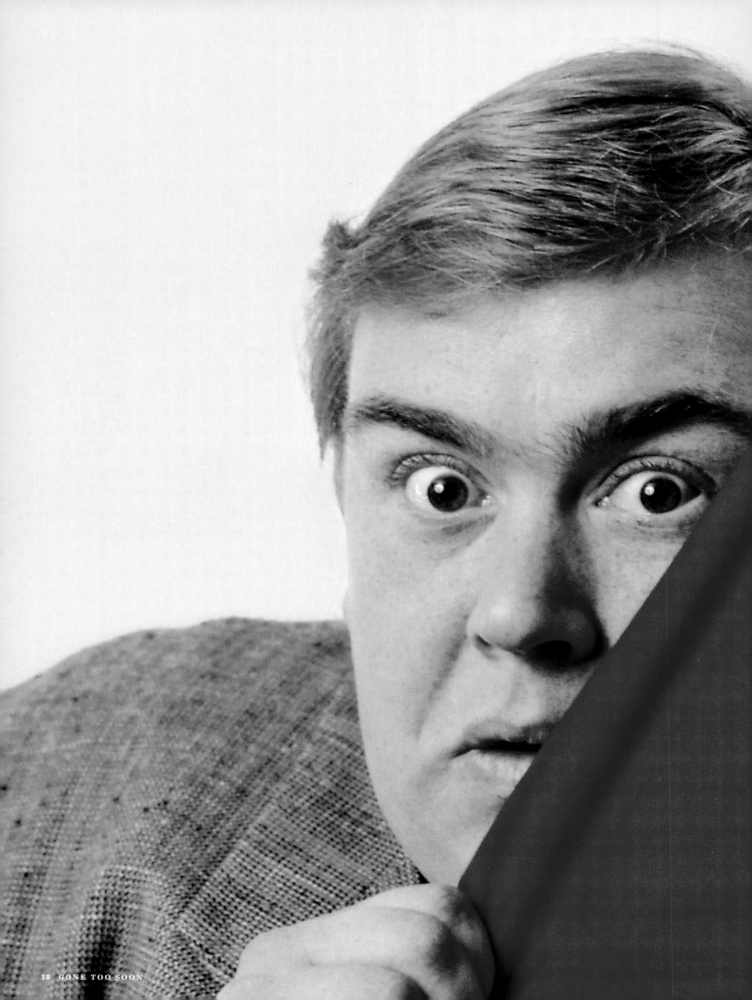

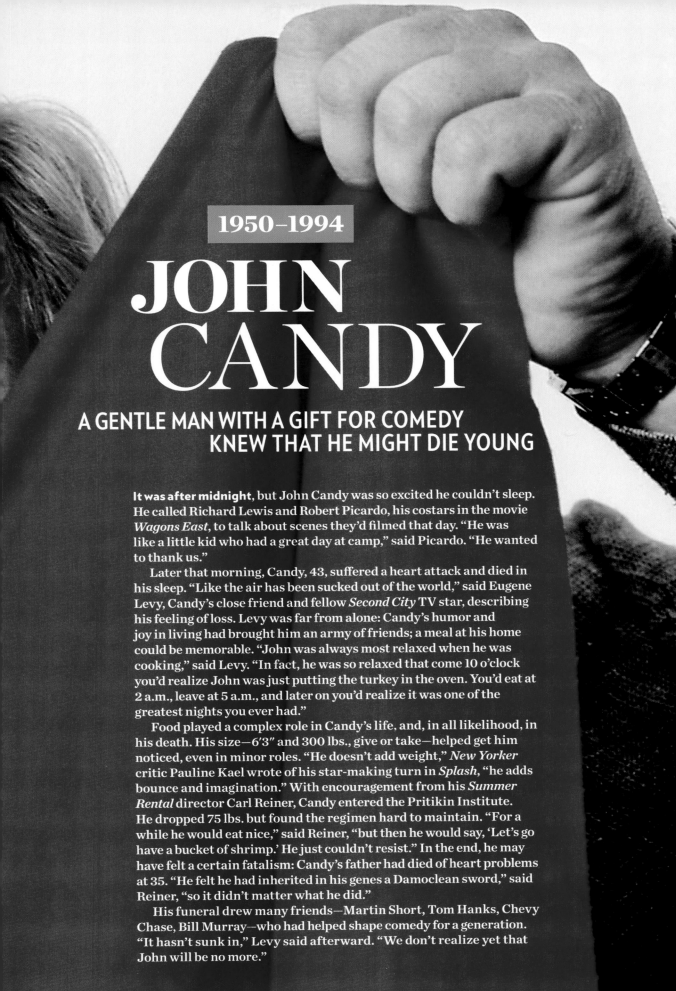

1950–1994

JOHN CANDY

A GENTLE MAN WITH A GIFT FOR COMEDY KNEW THAT HE MIGHT DIE YOUNG

It was after midnight, but John Candy was so excited he couldn't sleep. He called Richard Lewis and Robert Picardo, his costars in the movie *Wagons East*, to talk about scenes they'd filmed that day. "He was like a little kid who had a great day at camp," said Picardo. "He wanted to thank us."

Later that morning, Candy, 43, suffered a heart attack and died in his sleep. "Like the air has been sucked out of the world," said Eugene Levy, Candy's close friend and fellow *Second City* TV star, describing his feeling of loss. Levy was far from alone: Candy's humor and joy in living had brought him an army of friends; a meal at his home could be memorable. "John was always most relaxed when he was cooking," said Levy. "In fact, he was so relaxed that come 10 o'clock you'd realize John was just putting the turkey in the oven. You'd eat at 2 a.m., leave at 5 a.m., and later on you'd realize it was one of the greatest nights you ever had."

Food played a complex role in Candy's life, and, in all likelihood, in his death. His size—6'3" and 300 lbs., give or take—helped get him noticed, even in minor roles. "He doesn't add weight," *New Yorker* critic Pauline Kael wrote of his star-making turn in *Splash*, "he adds bounce and imagination." With encouragement from his *Summer Rental* director Carl Reiner, Candy entered the Pritikin Institute. He dropped 75 lbs. but found the regimen hard to maintain. "For a while he would eat nice," said Reiner, "but then he would say, 'Let's go have a bucket of shrimp.' He just couldn't resist." In the end, he may have felt a certain fatalism: Candy's father had died of heart problems at 35. "He felt he had inherited in his genes a Damoclean sword," said Reiner, "so it didn't matter what he did."

His funeral drew many friends—Martin Short, Tom Hanks, Chevy Chase, Bill Murray—who had helped shape comedy for a generation. "It hasn't sunk in," Levy said afterward. "We don't realize yet that John will be no more."

He had just wrapped the role of his life—as a jarringly clownish Joker in *The Dark Knight*—and was, it seemed, on the cusp of full-blown stardom. But Heath Ledger, a rugged young Aussie actor, would not live to see it: Early on Jan. 22, 2008, police found him in his $23,000-a-month Manhattan loft, dead from an accidental overdose. Friends said Ledger, 28, was known for his partying and drug use; at the time of his death he was also exhausted from the long *Batman* shoot, worn down by pneumonia and insomnia and depressed over his split from his *Brokeback Mountain* costar Michelle Williams, 28, the mother of their 3-year-old daughter, Matilda Rose, whom he hadn't gotten to see during the Christmas holidays. "He said, 'I'm missing my girl,'" recalled a friend who spoke with Ledger a day before his death. Weak and vulnerable, he overdosed on a cocktail of prescription sleep aids and antianxiety pills.

His death hit Hollywood hard—and devastated Williams. "It's one thing to lose someone close to you," said a friend. "But the fact that she lost Matilda's father is crushing." There were rumors about Ledger's last days (his massage therapist, who found the body, had phoned Mary-Kate Olsen before calling police) and reports of a rift over Leger's will, which was written before he met Williams and left his $20 million estate to his family in Australia (his father, Kim, later explained, "Our family has gifted everything to Matilda").

Williams stayed focused on Matilda, working to make sure her days were as normal as possible and that her father's spirit remained in her life. Said Williams: "All that I can cling to is his presence inside her that reveals itself every day. His family and I watch Matilda as she whispers to trees, hugs animals and takes steps two at a time, and we know that he is with us still. She will be brought up with the best memories of him."

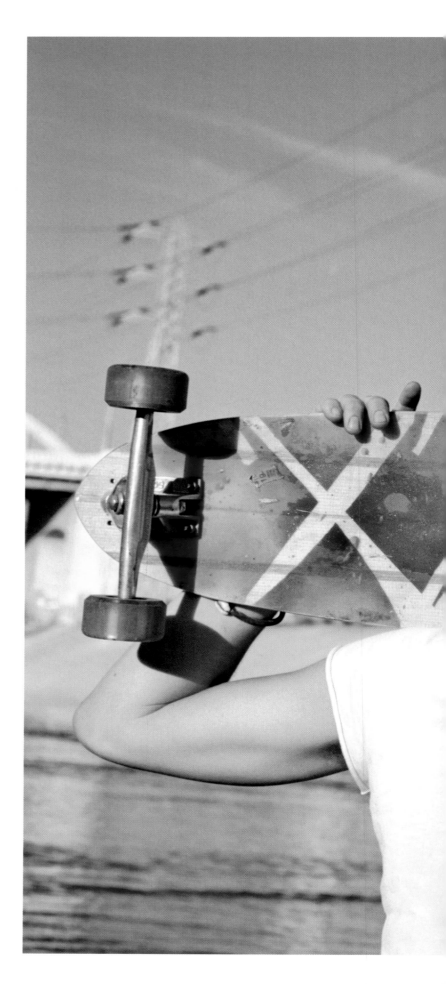

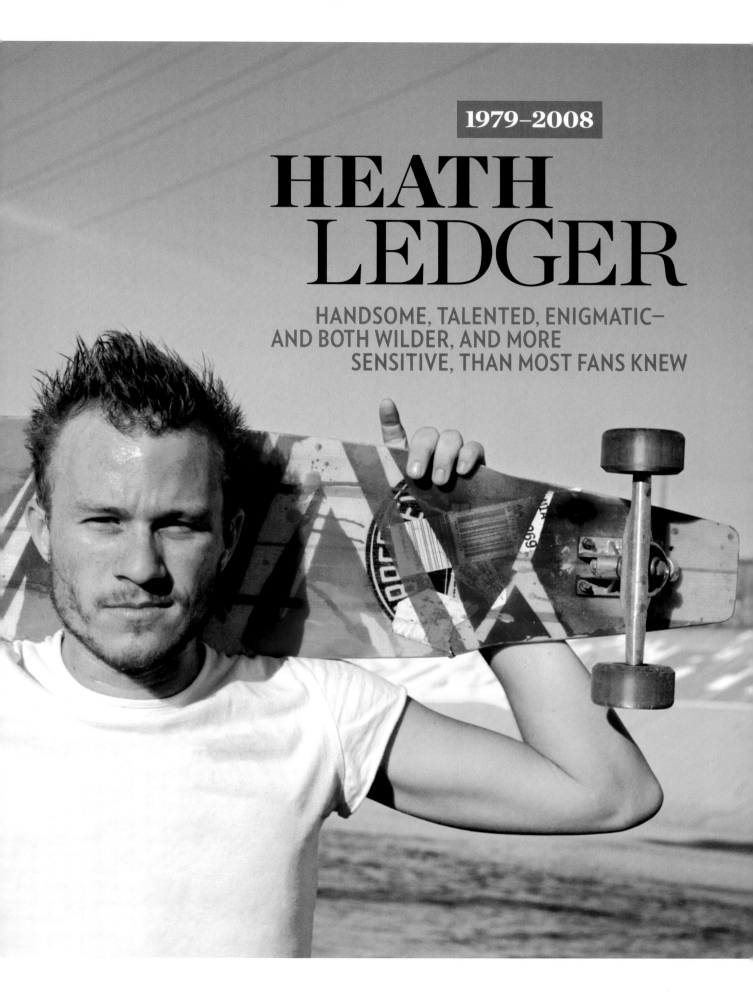

1979–2008

HEATH LEDGER

HANDSOME, TALENTED, ENIGMATIC—AND BOTH WILDER, AND MORE SENSITIVE, THAN MOST FANS KNEW

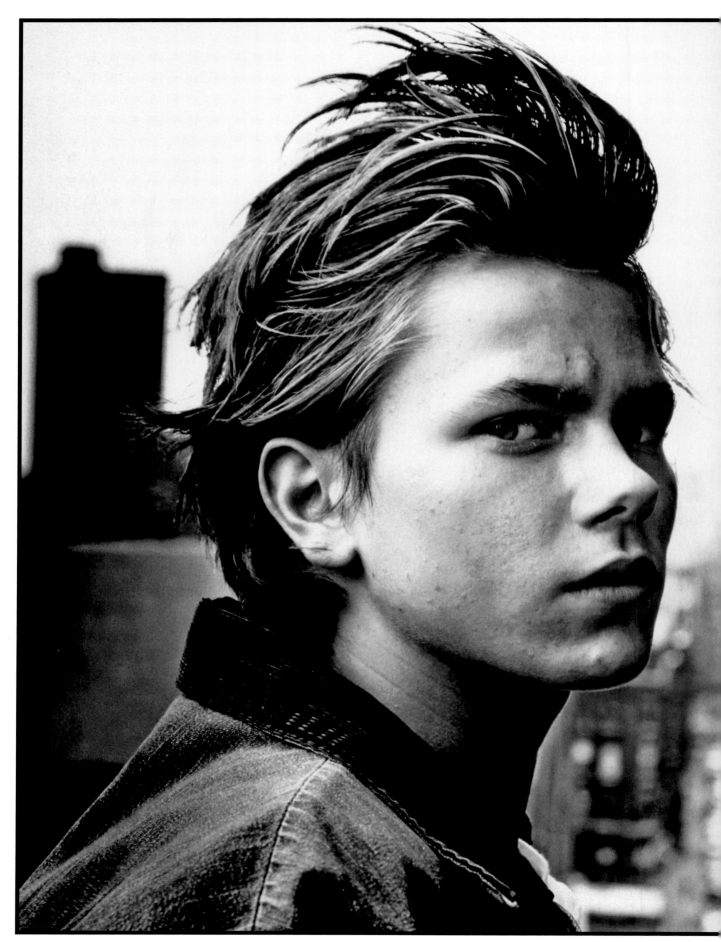

RIVER PHOENIX

TALENT, LOOKS, A BRIGHT FUTURE— AND A FATAL DRUG COCKTAIL

One a.m., Oct. 31, 1993, the very first hour of Halloween day. Outside the Viper Room on L.A.'s Sunset Strip, witches milled with harlequins and a Louis XIV wannabe, and few paid much attention to the young man who lay on the sidewalk, thrashing spasmodically. It was, after all, West Hollywood. "It looked," said one witness, "like a normal occurrence."

The crowd would have paid more attention if they'd recognized the young man: River Phoenix, 23, star of *Stand by Me* and one of the hottest young actors in Hollywood. In jeans and sneakers, he looked like any young clubgoer who had knocked back too many or inhaled too much. But by the time an ambulance delivered him to Cedars-Sinai Medical Center at 1:34, he was in full cardiac arrest. At 1:51, River Phoenix was dead.

To many his death was doubly shocking: Not only *that* he had died, but how. A vegetarian and environmental activist, Phoenix didn't come across as a nightlife berserker. "I'm in shock," said his grandmother Margaret Dunetz. "I can't describe what a wonderful kid he is. I can't understand why—how—it could happen." Said Dan Mathews, director of International Campaigns for PETA: "The hardest drink I ever saw him drink was carrot juice."

But few people saw all sides of Phoenix; as he himself once remarked, "I have a lot of chameleon qualities—I get very absorbed in my surroundings." And although his background was colorful enough— raised by hippyish parents in an Oregon log cabin, he later moved with his family to Venezuela after his mother and father joined a religious cult—he seldom told his life story the same way twice. "I have lied and changed stories and contradicted myself left and right," he told a reporter days before his death, "so that at the end of the year you could read five different articles and say, 'This guy is schizophrenic.'"

An autopsy determined that Phoenix had died from "multiple drug intoxication," including heroin, cocaine and an over-the-counter cold medicine. Three years earlier, when his *Stand by Me* costar Corey Feldman was arrested for heroin possession, Phoenix gave a response that, later, would seem sadly prescient. "It makes you realize drugs aren't just done by bad guys and sleazebags," he said. "It's a universal disease."

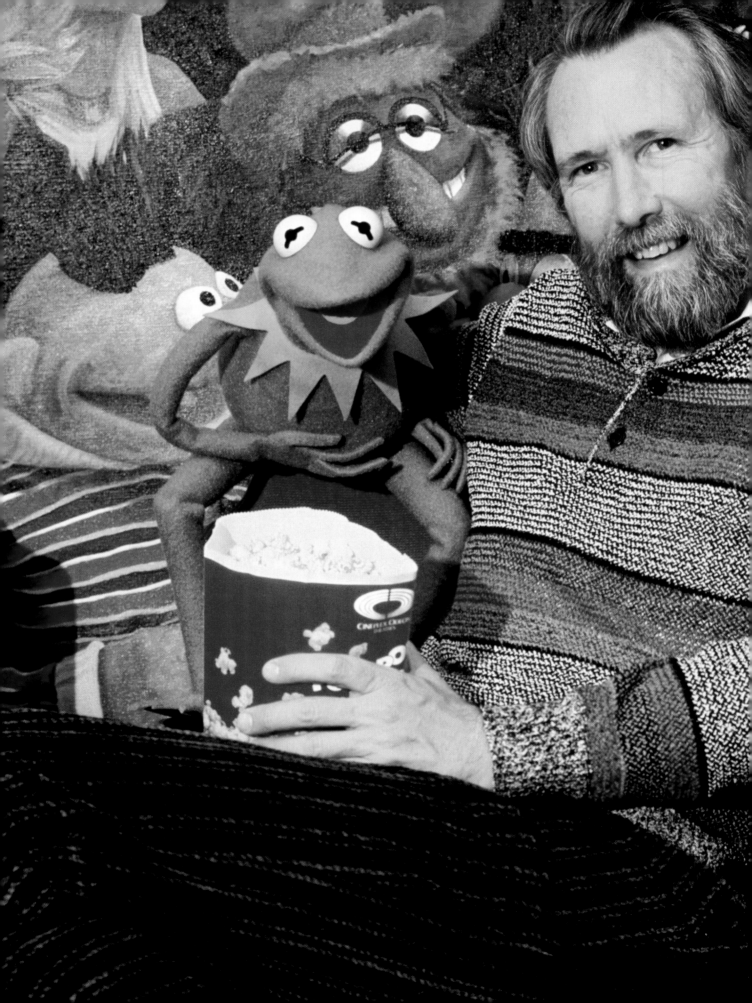

JIM HENSON

CHILDREN'S TELEVISION'S GENTLE GENIUS WALKED SOFTLY AND LET A FROG DO THE TALKING

There may be no greater tribute to Jim Henson than this: Miss Piggy once danced *Swine Lake* with Rudolf Nureyev and, on another occasion, joined Beverly Sills to sing *Pigaletto.* Seldom, if ever, had so many stars— over the years, there were scores—been upstaged voluntarily by a pig.

That desire to join in the fun was testimony to the talent and sheer joy that radiated from Henson's most famous creations, *Sesame Street* and *The Muppets.* "Jim was an authentic American genius," said Children's Television Workshop's Joan Ganz Cooney. "He was our era's Charlie Chaplin, Mae West, W.C. Fields and Marx Brothers."

No one, Henson included, had any idea how sick he really was when he arrived at New York Hospital's emergency room on May 15, 1990. By then, doctors said, he was already in "acute respiratory distress," suffering from a virulent bacterial infection, heart and kidney failure and shock. He died within a day. "Possibly, had he been admitted earlier, something could have been done," said a hospital spokesman. Henson was 53.

Famously shy, Henson usually let his alter ego, Kermit the Frog, do the talking. The two were so closely linked that children, spotting Henson strolling in New York's Central Park, would shout out, "Look! There's Kermit!" Nothing, it seemed, pleased him more.

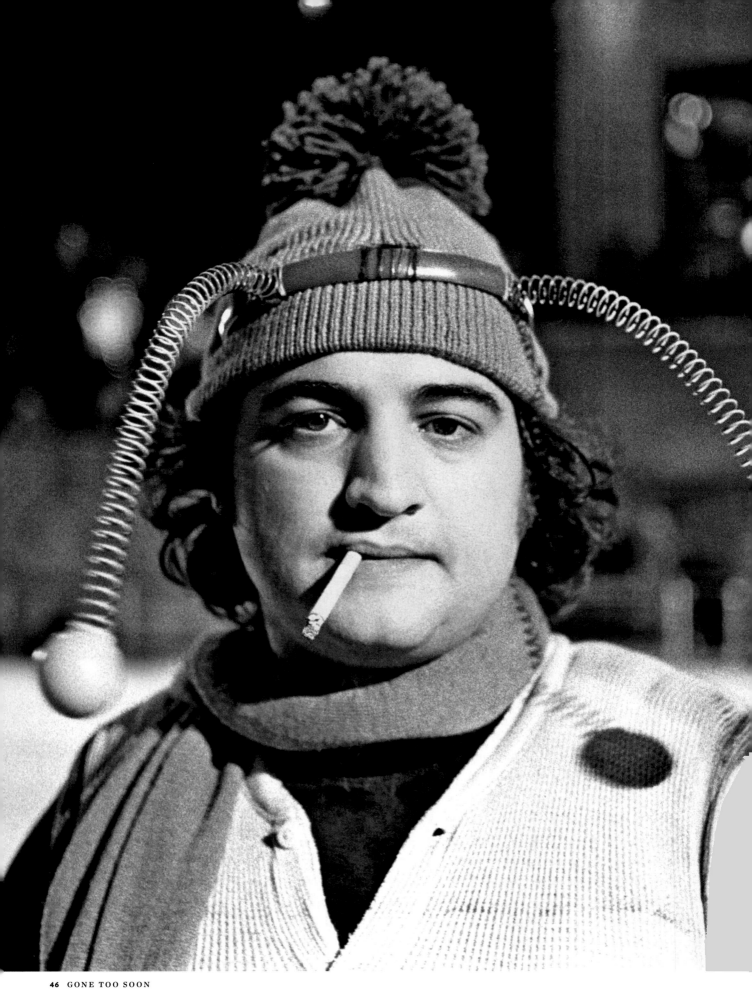

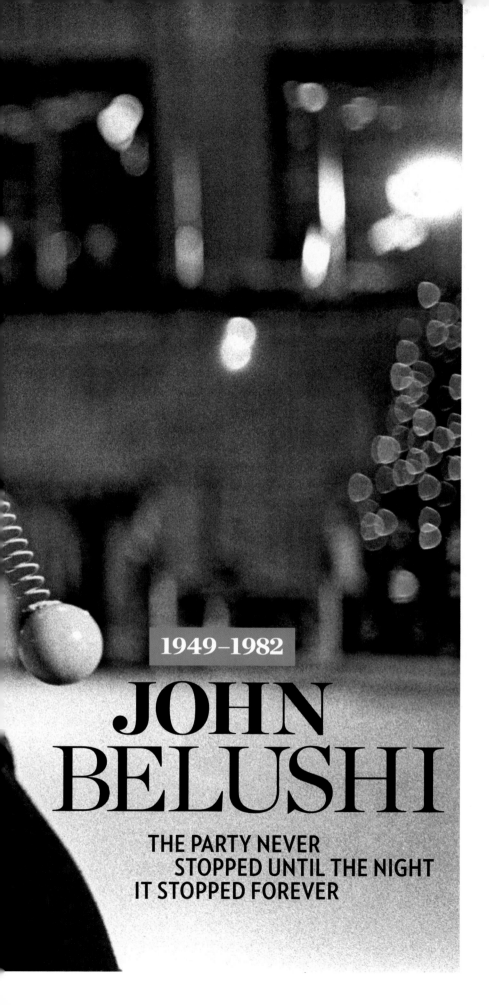

1949–1982

JOHN BELUSHI

THE PARTY NEVER STOPPED UNTIL THE NIGHT IT STOPPED FOREVER

For comedian John Belushi, it was a night like any other: Frantic and drug-fueled, the former *Saturday Night Live* star first stopped, around 9 p.m., at On the Rox, a private club known for spontaneous entertainment provided by visiting stars. Belushi was introduced to singer Johnny Rivers and hung out with actors Robert De Niro and Harry Dean Stanton, television writer Nelson Lyon, and Cathy Smith, a known drug dealer. Later, according to Lyon's court testimony, Belushi returned to his bungalow at the Chateau Marmont and was visited briefly by comedian Robin Williams. At some point after Williams left, Smith injected Belushi with a "speedball," a combination of heroin and cocaine. The next day he was found dead from an overdose.

All who knew him were saddened; few who knew him well were completely surprised. As former *Saturday Night Live* writer Michael O'Donoghue had chillingly observed years before, "The same violent urge that makes John great will also ultimately destroy him. He's one of those hysterical personalities that will never be complete. I look for him to end up floating dead after the party." Belushi—who, an associate noted, ingested everything from "ethyl chloride to Quaaludes"—was not unaware of the risks his lifestyle posed.

Once, clowning around with *National Lampoon* cofounder Doug Kenney, Belushi had done an impromptu impression of Elvis Presley in his death throes. Kenney told him it wasn't funny. "But," Belushi replied, "that's the way we're all going to die, Dougie."

The face of comedy (clockwise from top, left): Belushi as the head Conehead; a Blues Brother; an *SNL* samurai; and a fighter pilot in the film *1941*.

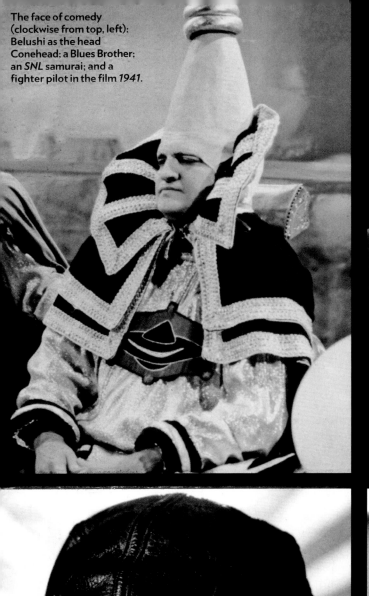

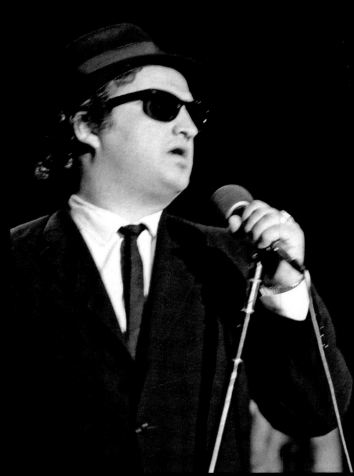

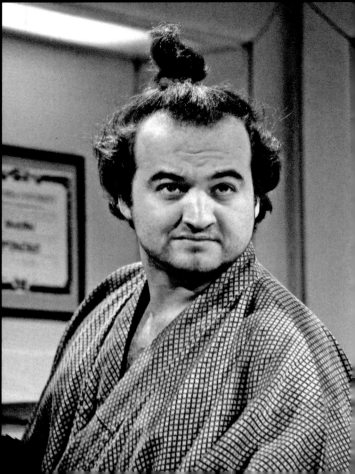

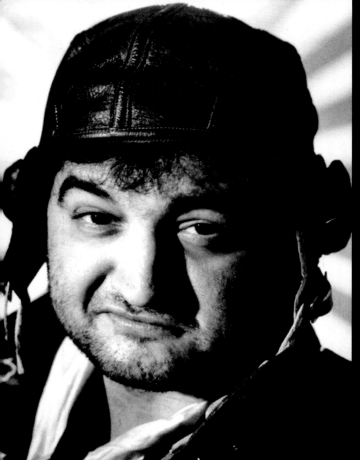

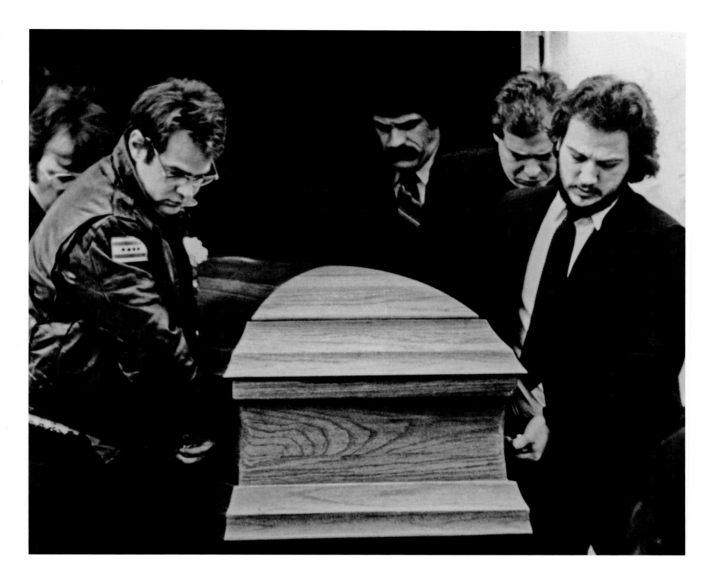

Belushi's philosophy was simple and direct: He believed in entertainment, exuberance and anarchy. "What rock and roll was supposed to be about was getting loose, enjoying it, going a little crazy and not caring how you act or dress," he once said. "Now rock and roll is at a standstill, I think—and comedy is taking its place as something exciting."

As a wild man, Belushi, the son of Albanian immigrants who settled in Wheaton, Ill., had been, curiously, something of late bloomer. "Everyone said he was loud and raucous," recalled a childhood neighbor, "but it was always 'Yes, sir' and 'No, sir' with me." He did like attention, and was a star linebacker on his high school football team and elected homecoming king his senior year. At Illinois's College of DuPage, Belushi began doing comedy routines. When Jayce Sloane, an associate producer from Second City, the famous Chicago comedy troupe, called to try to book the group on campus, a DuPage official told her, "We don't need Second City. We've got a student who goes to see your shows and

comes back and does it for us." Belushi later auditioned for Second City—and, Sloan recalled, "blew everyone away."

After honing his craft there, he was hired to appear in *National Lampoon's Lemmings* off-Broadway. Many of its stars later joined the original cast of *Saturday Night Live*. "He walked into my office and started to abuse me," *SNL* producer Lorne Michaels recalled. "He said, 'I can't stand television,' and that was just the kind of abuse I wanted to hear." His performances—as a killer bee, a samurai tailor, Joe Cocker or the "no Coke, Pepsi!" diner owner—were an instant hit with audiences. "[Chevy] Chase was the first star of the show," said NBC exec Dick Ebersol, "but Belushi was the first to become the audience's friend. There was a huge bond." It only grew stronger when Belushi, as proto-frat-boy Bluto Blutarski, an id in a toga, helped make the movie *Animal House* a huge hit.

Belushi is buried on Martha's Vineyard in Massachusetts. His headstone reads, "I may be gone, but rock and roll lives on."

Belushi "seemed to represent everyone's rebelliousness," said a Second City friend. "He was everyone's free spirit." Pal Dan Aykroyd (above left, in leather) and brother Jim Belushi (bearded) helped carry the comedian's casket.

He was given up for adoption at one day old and starred in a TV hit, *Diff'rent Strokes*, while still in grade school. When that ended, Gary Coleman embarked on the familiar and depressing journey of many former child stars, made worse by medical problems—kidney failure as a child led to his diminutive stature—and financial trouble. "I have four strikes against me," he said in 1999. "I'm black. I'm short. I'm intelligent, and I have a medical condition." He took odd jobs—including, famously, a stint as a mall cop—behaved badly and was mocked by comedians.

Even after he died, at 42, in Utah following a brain hemorrhage, the sad show continued as an ex-wife and ex-girlfriend battled over what little was left of his millions. His Rosebud, it seems, was model trains: Coleman had an enormous collection and sometimes worked in a Culver City hobby shop. "That was his big escape," said Allied Model Trains' Fred Hill. "The customers loved him, and he loved the attention."

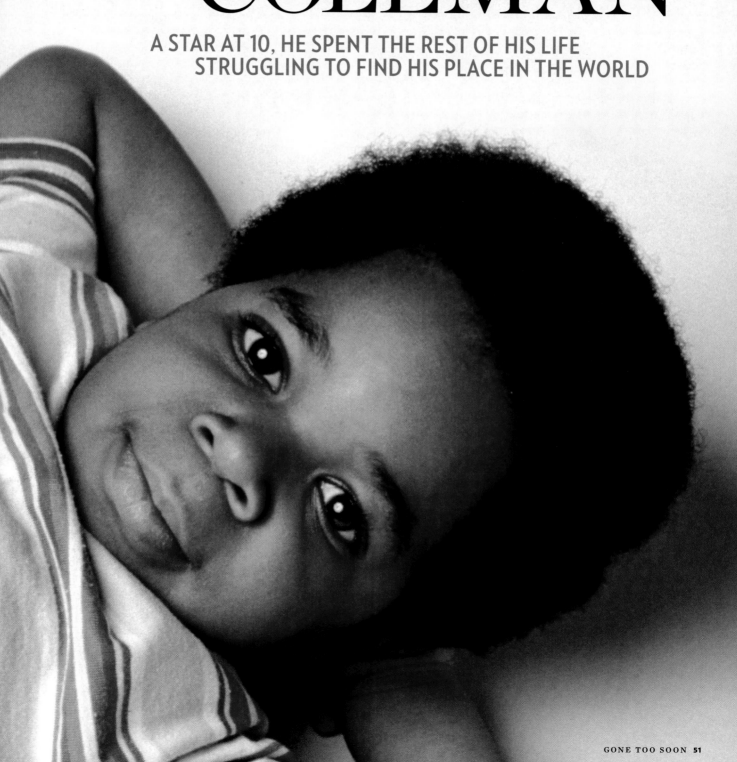

GARY COLEMAN

A STAR AT 10, HE SPENT THE REST OF HIS LIFE STRUGGLING TO FIND HIS PLACE IN THE WORLD

She was a beautiful young actress who, at 21, had costarred in a CBS sitcom, *My Sister Sam*, and was beginning to land movie roles. He was nondescript, a guy in a yellow polo shirt who had been seen wandering her L.A. neighborhood, holding out a publicity photo and asking strangers if they knew where Rebecca Schaeffer lived. "I just looked at him and said, 'What?'" recalled a woman who encountered him outside a market. "He looked weird." Another local bumped into him twice. "It was strange seeing him twice," she said. "You think about it for a second and then go your own way. That's what you do in L.A."

Later he was seen getting out of a cab outside Schaeffer's apartment building. Shortly thereafter, neighbors heard a shot and two screams. "It was bloodcurdling," said Richard Goldman, who lived across the street. Another neighbor saw Schaeffer's body lying in her doorway. "Her eyes were open and glazed over," he said. "I took her pulse, and there was no beat." She had been shot once, in the chest. The man in the yellow shirt was seen jogging down the block.

Within days police arrested Robert John Bardo, 19, a troubled fan. A friend of his said Bardo had become obsessed with Schaeffer, written her a love letter and threatened to hurt her.

The murder shocked America in general and Hollywood in particular. Until then it was possible to see the shooting of John Lennon, nine years earlier by Mark David Chapman, as a bizarre but isolated incident; Schaeffer's death suggested that, late in the 20th century, even a little fame could have tragic consequences.

1967–1989

REBECCA SCHAEFFER

A CRAZED FAN MURDERS A BEAUTIFUL YOUNG ACTRESS—AND SENDS SHOCK WAVES THROUGH HOLLYWOOD

BRITTANY MURPHY

YOUNG ACTRESS, SURPRISING DEATH

Years later, there are still more questions than answers. On Dec. 20, 2009, actress Brittany Murphy, 32, who broke through in *Clueless* and played Eminem's girlfriend in *8 Mile*, was found dead in her Hollywood Hills home. Her thin frame and party-girl past led to speculation that illegal drugs may have played a role. But the coroner's report, released two months later, told a simpler story: Murphy, who had been suffering flu-like symptoms, died of pneumonia, with prescription drugs—including the painkiller Vicoprofen and the antidepressant Fluoxetine—and anemia as contributing factors. Her husband, British screenwriter Simon Monjack, 40, said he had no idea she was so sick. "I am feeling beyond devastated," he said.

But the story didn't end there. Monjack, a mysterious character who had a history of financial problems, was accused by Murphy's former business manager of draining her accounts of hundreds of thousands of dollars in the weeks after her death.

Before that could be resolved, however, the case took another tragic twist: On May 23, 2010, Monjack was found dead in the same bedroom in which his wife had died. Although he had prescription drugs in his system, they weren't at lethal levels: Like Brittany, the coroner determined, he died of pneumonia.

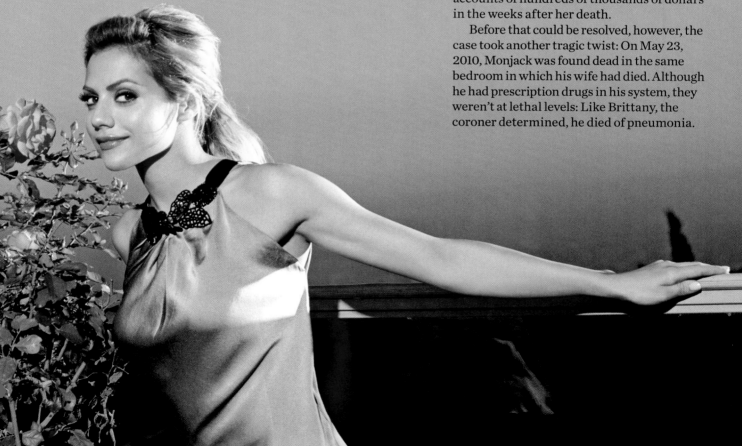

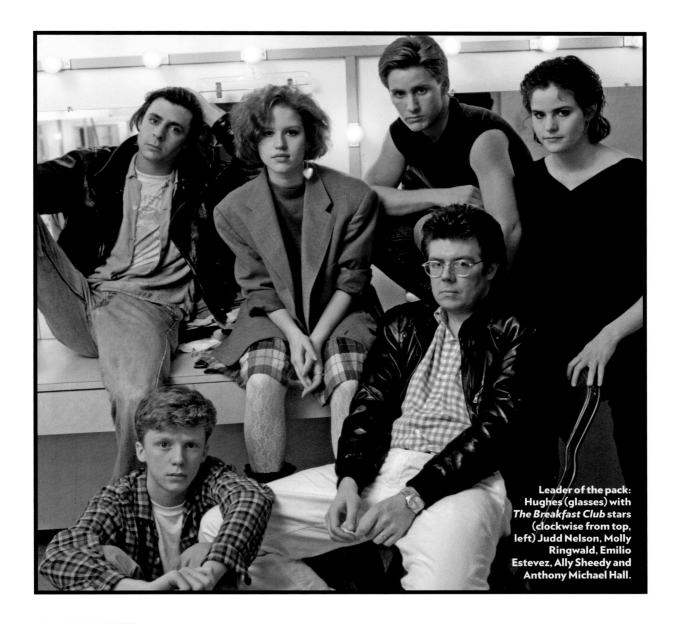

Leader of the pack: Hughes (glasses) with *The Breakfast Club* stars (clockwise from top, left) Judd Nelson, Molly Ringwald, Emilio Estevez, Ally Sheedy and Anthony Michael Hall.

1950–2009

JOHN HUGHES

FILMDOM'S BOSWELL-OF-THE-'BURBS MADE TEEN MOVIES WITH WIT AND HEART

One of the 1980s' most influential filmmakers, Hughes crafted hit after coming-of-age hit, including *Sixteen Candles*, *The Breakfast Club* and *Ferris Bueller's Day Off*, forever defining what it meant to be a teen in suburbia. "He knew teenagers because he was one himself," said Kelly LeBrock, star of his 1985 comedy *Weird Science*. "He was always running around with high-top sneakers with no laces in them."

Hughes, who died of a heart attack at 59, never cared much for Hollywood, leaving it behind in the '90s for the Midwest, where he set many of his films. The director, survived by his wife of 39 years, Nancy, and two grown sons, did what many of his movies' grown-ups didn't—spent time with his kids. While filming *Pretty in Pink*, "He'd invite me over to the house and they'd all be jumping around the pool," said James Spader. "He protected them, and I think that's why he left Hollywood."

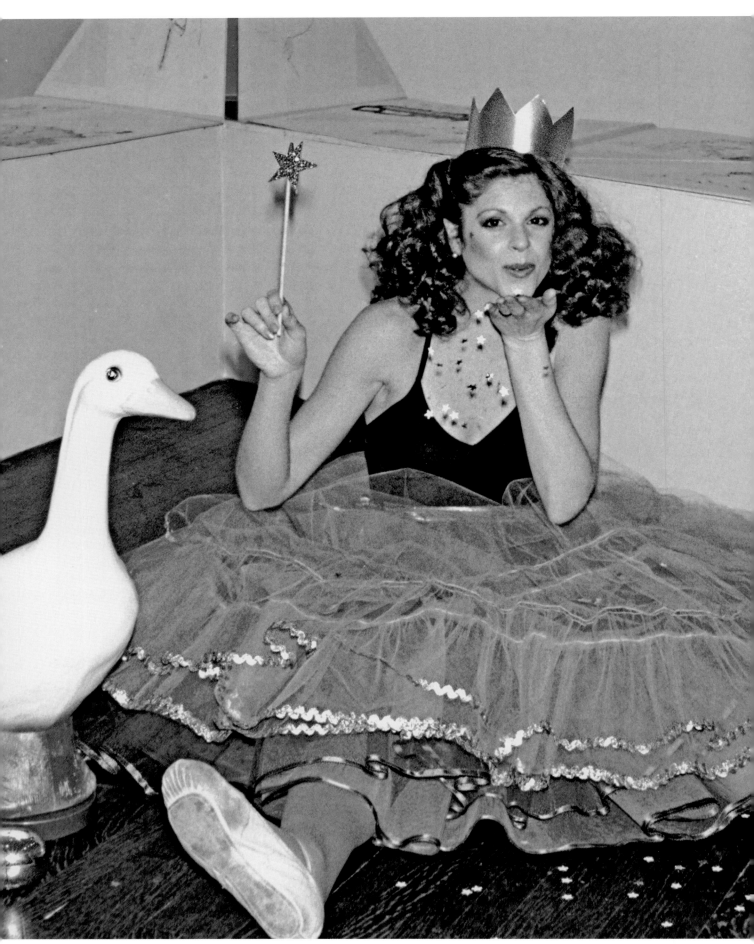

1946–1989
GILDA RADNER

THE QUIRKY GIRL ON THAT NEW SKETCH-COMEDY SHOW BECAME EVERYBODY'S FAVORITE SATURDAY-NIGHT DATE

Lisa Loopner, Baba Wawa, Roseanne Roseannadanna, Emily Litella: Different characters, but all shared the same goofy, childlike DNA. "So much of what made up her characters didn't come of dreaming that stuff up," said a friend of *Saturday Night Live* star Gilda Radner. "They evolved from her being so open to the funniness in life." Said Anne Beatts, an early *SNL* writer: "If *Saturday Night Live* was like Never-Never-Land, the Island of Lost Boys, she was Tinker Bell. She just hadn't lost touch with the child in her."

She got her start, like so many *SNL* alumni, in Toronto's Second City comedy troupe. Producer Lorne Michaels recalled being impressed by such peculiar Radner abilities as "playing 14 Bingo cards at a time" or "remembering everything she'd eaten that day. She'd just literally reel it off—the french fries off someone else's plate, a Milk Dud from the bottom of her purse." When *SNL* premiered in 1975, "What Gilda Ate" became a regular segment.

Radner met Gene Wilder while making the 1982 film *Hanky Panky.* "There was a chemistry that was palpable," said a friend who visited the set. "They hadn't yet been together, but there was no chance that they weren't going to be." Wilder "was funny and handsome," Radner wrote. "And he smelled good." They married in 1984.

Two years later, Radner was diagnosed with ovarian cancer. For 2½ years, through 30 radiation treatments, she fought heroically. "My life had made me funny," Radner wrote in *It's Always Something,* her book about coping with the disease, "and cancer wasn't going to change that." Typically, she used her experience to help others. "I went bald because of chemotherapy," recalled Melinda Sheinkopf, a cancer survivor who had met Gilda. "She made it bearable. She brought me curlers, mousse and gel in a little bag. I laughed myself silly."

Radner lost her own battle, in her sleep, on May 20, 1989. She was 42.

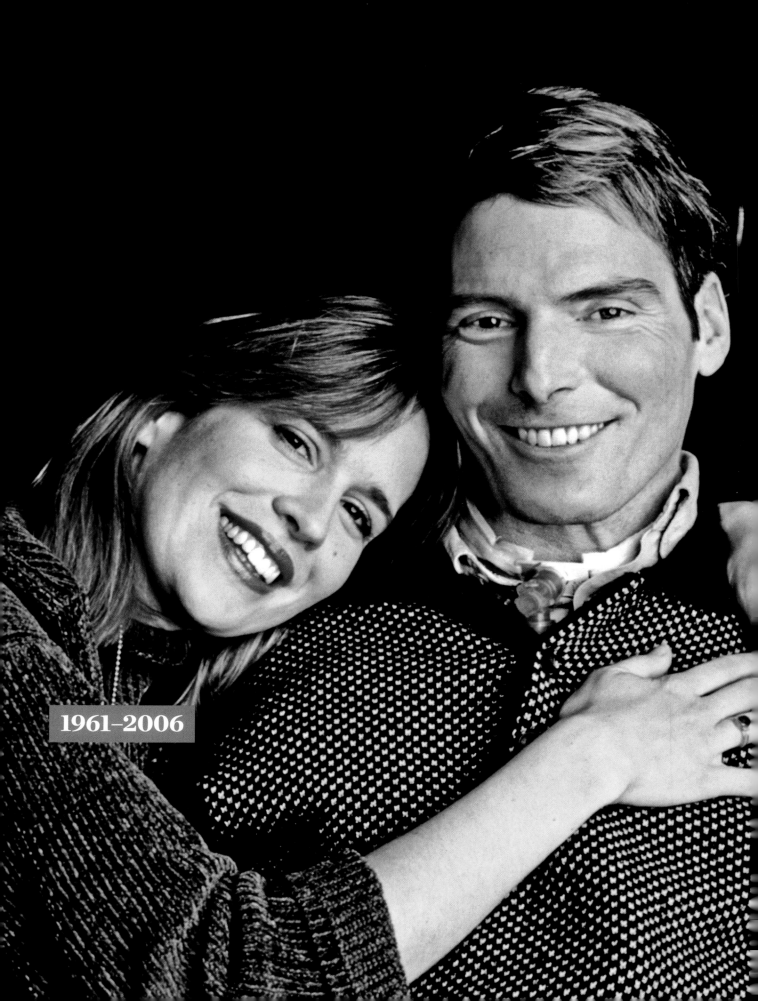

1961–2006

CHRISTOPHER & DANA REEVE

"YOU'RE STILL YOU," SHE SAID AFTER HIS ACCIDENT. "AND I LOVE YOU"

1952–2004

Dana Reeve was performing in a play in Costa Mesa, Calif., when the call came. "She was trembling, but she stayed focused," said Mimi Lieber, another actress in the cast. "She asked, 'Do I need to get a plane?' And the nurse on the phone said yes. She asked, 'Could he die?' And the nurse said yes. And then she asked, 'Do I need to call the kids?' And the nurse said yes."

Dana Reeve raced home to Connecticut, where her husband, actor Christopher Reeve, 52, paralyzed in a riding accident a decade before, had been hospitalized after developing a sudden, raging infection. At 5:20 p.m. the next day, his family gathered around him, his heart gave out. "I think," said Lieber, "he waited for her."

Christopher had been a strapping, 6'4" leading man, the star of four *Superman* movies, before crushed vertebrae cost him almost all feeling below his neck and tethered him to a respirator. He later said that he thought of letting go of life altogether, until Dana uttered the words that saved him: "You're still you, and I love you." Together they built a brave new life, focused on their young son Will and, through the Christopher Reeve Paralysis Foundation, on raising millions for spinal cord research and helping others in the same situation. "Chris had far greater challenges than I've faced, and faced them with courage, intelligence and dignity I can only aspire to," said his friend Michael J. Fox, who has Parkinson's disease. "If he could ever have walked, he would have walked over to help someone else get up." What *did* upset Reeve? "I get pretty impatient," he once said, "with people who are able-bodied but are somehow paralyzed for other reasons."

Tragically, even after Christopher's death, more heartbreak followed: Nine months later, Dana was diagnosed with lung cancer. She fought bravely, spoke publicly and did everything in her power to comfort and provide for Will, then 13. (He would later move in with family friends.) She died, age 44, 17 months after Christopher. "Her compassion, her fortitude are a source of inspiration," said a friend. "Her impact is immeasurable."

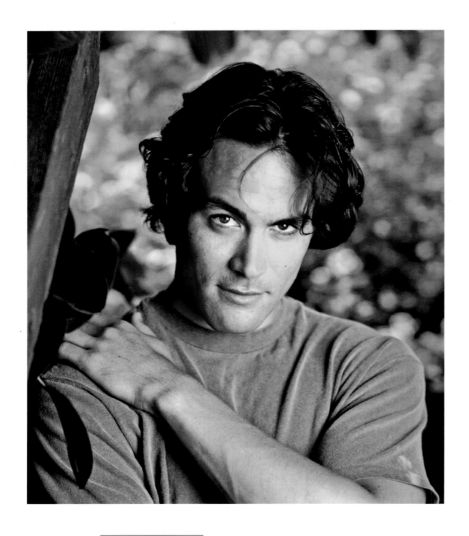

1965–1993

BRANDON LEE

A GUN CONTAINING BLANKS KILLS BRUCE LEE'S SON

The son of martial-arts star Bruce Lee, Brandon Lee grew used to, but didn't always enjoy, the inevitable comparisons. "When you have a built-in comma after your name," he said, "it makes you sensitive."

Especially, no doubt, when you make your living in the same line of work. Filming *The Crow*, about a rock star who comes back from the dead to avenge his own murder, in Wilmington, N.C., the younger Lee had just begun to make a name for himself in action films. Shortly after midnight on March 31, while filming a scene in which his character got shot, he slumped to the floor—but he wasn't acting. Although the gun fired by a fellow actor contained blanks, somehow a metallic fragment ripped through Lee's abdomen and lodged in his spine.

Doctors at a nearby hospital tried for five hours to stop the bleeding. Lee's fiancée, casting assistant Lisa Hutton, 29, arrived shortly before he died. Lee was 28; his father, Bruce, had died of brain edema at 32.

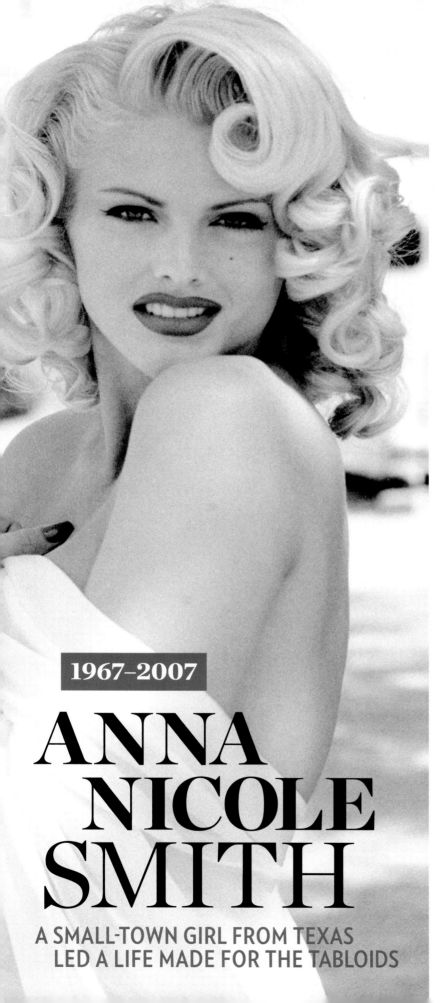

ANNA NICOLE SMITH

A SMALL-TOWN GIRL FROM TEXAS LED A LIFE MADE FOR THE TABLOIDS

In the end, it was a sad circus, a perfect storm of drugs, paternity claims, contested wills, tabloid headlines, a motherless child and Zsa Zsa Gabor's eighth husband, Prince Frederic von Anhalt. Stories about the death of Anna Nicole Smith likened it to that of her idol, Marilyn Monroe—two buxom platinum blondes who'd come to Hollywood, found fame and died young. It was, of course, a facile comparison: Monroe's life had featured real glamour, memorable movies—*Bus Stop, Some Like It Hot*—and an all-star cast that included Joe DiMaggio, Arthur Miller and Robert Kennedy. Anna Nicole Smith was famous mostly for trying very hard to be famous, from *Playboy* covers to her 2002 E! reality series, *The Anne Nicole Show.* Her manager/lover/ publicist/caretaker, lawyer Howard K. Stern was many things, but he was, certainly, no Jack Kennedy.

The end probably began shortly after the Texas-born Smith, then 39, gave birth to a daughter, Dannielynn, on Sept. 7, 2006, in the Bahamas. Days later her son Daniel, 20, who had been visiting, died of what doctors determined was a combination of antidepressants and methadone. Smith was devastated; simultaneously, she was forced to cope with a newborn, mourn her son, battle a paternity suit from former lover Larry Birkhead, 34, who claimed to be Dannielynn's dad (so, among others, did Frederick von Anhalt), and a fight over ownership of the Bahamas house she was living in.

On Feb. 5, Smith checked into the Seminole Hard Rock Hotel & Casino in Hollywood, Fla. "She seemed a little woozy," said a witness who saw her in the lobby. "She was walking straight but was being held up by Howard." Three days later, her nurse found her unconscious in her room; emergency personnel couldn't revive her, and she died shortly after arriving at Memorial Regional Hospital. An autopsy found that she had died of an accidental overdose of prescription drugs.

After months of legal maneuvering and headline-producing hearings, Birkhead, a photographer, was determined to be the father of Dannielynn and granted custody. Ex-boyfriend Stern remained executor of Smith's will. Smith's estate lost a 15-year suit against the estate of J. Howard Marshall, II— the Texas billionaire she married when she was 26 and he was 89—though Dannielynn was the sole heir of her mother's $6 million fortune.

COREY HAIM

A CHILD STAR—AND A CAUTIONARY TALE

When you're 15 and there's a Ferrari you just bought and you can't even drive, and all the most beautiful girls in the world—a lot of them older—[are] hitting on [you]," said a friend, "it throws you for a loop."

Sadly, that's a pretty good description of Corey Haim's short life. A teen-throb sensation in movies like *The Lost Boys*, he slipped into addiction and never escaped. Toward the end of his life he dedicated himself to helping his mother, Judy, fight breast cancer. "He wanted to do everything in his power to help her beat it," said a friend. "He went to every doctor appointment with her and did everything to be a best friend to her." His relationship with his mother was so close, said pal Corey Feldman, that "the guy was 38 years old and living with his mom—and never even *thought* about not living with his mom."

Despite his new sense of purpose, Haim, said Feldman, was "still quietly battling drug addiction." And, Feldman added, Haim, a talented "manipulator, as good addicts are . . . always found somebody who was willing to give him large quantities of drugs." Indeed, although a coroner determined that drugs did not play a role in the 38-year-old actor's death—blamed on heart and lung problems— an investigation revealed that, by "shopping doctors," Haim had obtained 553 pills, including Vicodin, the week before he died.

By then the former actor was so far from stardom that his family had to auction off some of his belongings to pay for his funeral.

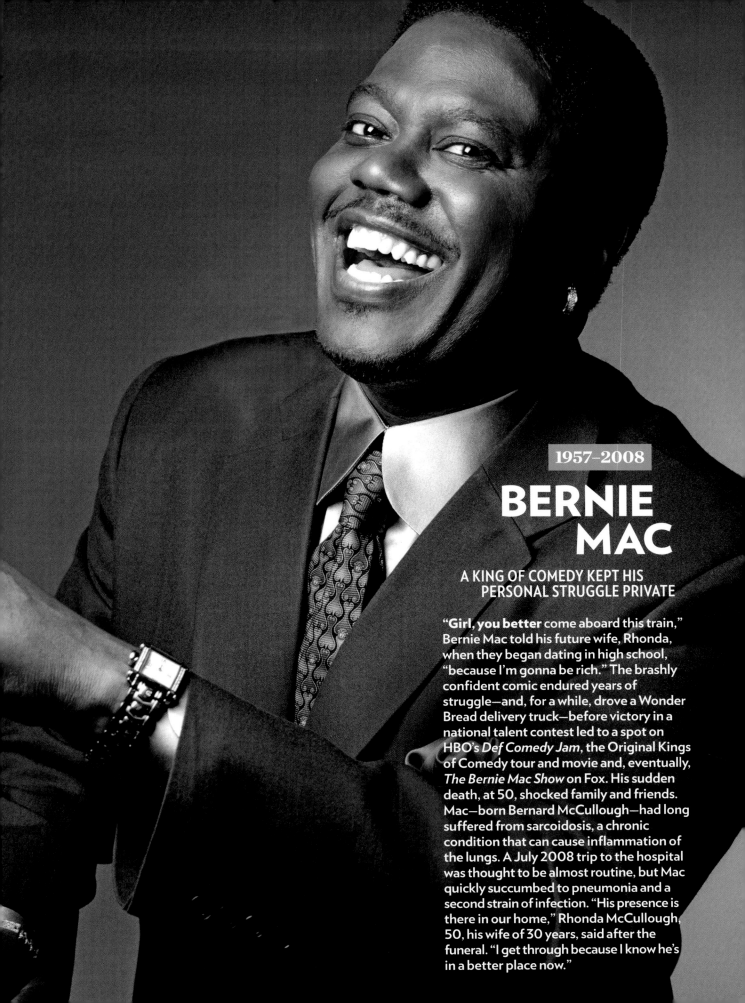

1957–2008

BERNIE MAC

A KING OF COMEDY KEPT HIS PERSONAL STRUGGLE PRIVATE

"Girl, you better come aboard this train," Bernie Mac told his future wife, Rhonda, when they began dating in high school, "because I'm gonna be rich." The brashly confident comic endured years of struggle—and, for a while, drove a Wonder Bread delivery truck—before victory in a national talent contest led to a spot on HBO's *Def Comedy Jam*, the Original Kings of Comedy tour and movie and, eventually, *The Bernie Mac Show* on Fox. His sudden death, at 50, shocked family and friends. Mac—born Bernard McCullough—had long suffered from sarcoidosis, a chronic condition that can cause inflammation of the lungs. A July 2008 trip to the hospital was thought to be almost routine, but Mac quickly succumbed to pneumonia and a second strain of infection. "His presence is there in our home," Rhonda McCullough, 50, his wife of 30 years, said after the funeral. "I get through because I know he's in a better place now."

Chris Farley, sweat pouring down his face, clutched his chest and yelled, "I'm about to have a heart attack!" It was a joke; partying wildly at the Chicago club Karma, the colossal comic was doling out $50 tips and doing his usual over-the-top comedy bits for fans.

Four days later, on Dec. 18, 1997, Chris's brother John found the 5'8", 296-lb. actor sprawled in the foyer of his 60th-floor apartment, dead, doctors said later, from an accidental drug overdose. In the previous week Farley, who made his name on *Saturday Night Live* and in movies, had freebased cocaine, according to a witness; hit so many clubs that even Chicago Bull's wildman Dennis Rodman, who'd bumped into him, said he was partying "too much"; and hired exotic dancers to entertain him at home. One dancer said she had spent Wednesday, the day before Farley died, watching him consume large quantities of cocaine, heroin and vodka.

"There was a hyperawareness of what was going on with Chris," said former *SNL* castmate Al Franken, but pals—and Farley himself, who had tried numerous stints at rehab—seemed powerless to stop it. Although he made up to $5 million per film, friends say he never felt he fit in. "He always said, 'They come to see the fat boy fall down,'" said a producer who had helped launch his career. "But I don't think he liked being the fat boy." Said his former drug counselor: "Chris thought he needed to be loaded to excess in order to be accepted."

A shy Catholic kid from Wisconsin, Farley, 33, had continued to attend Mass, even on the Sunday before he died. "Lust, gluttony, booze and drugs are most of the things I confess to," he once told a reporter. "I can't help it. I want to be a good Catholic, but I'm a hedonist."

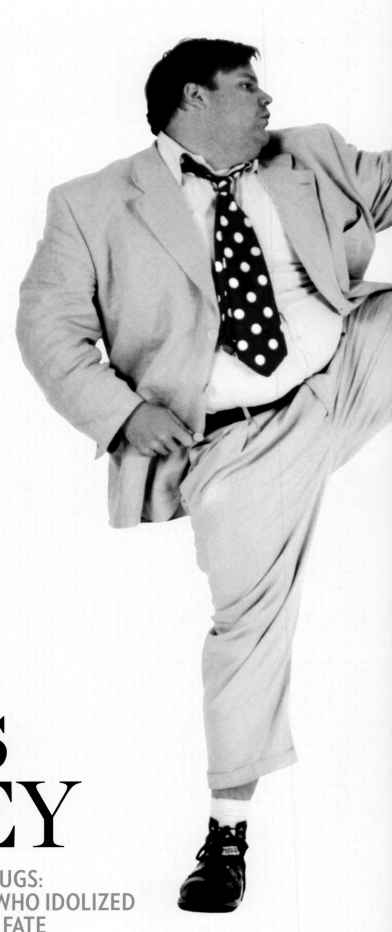

1964–1997

CHRIS FARLEY

LAUGHTER, SADNESS AND DRUGS: A COMIC HEAVYWEIGHT WHO IDOLIZED JOHN BELUSHI MEETS THE SAME FATE

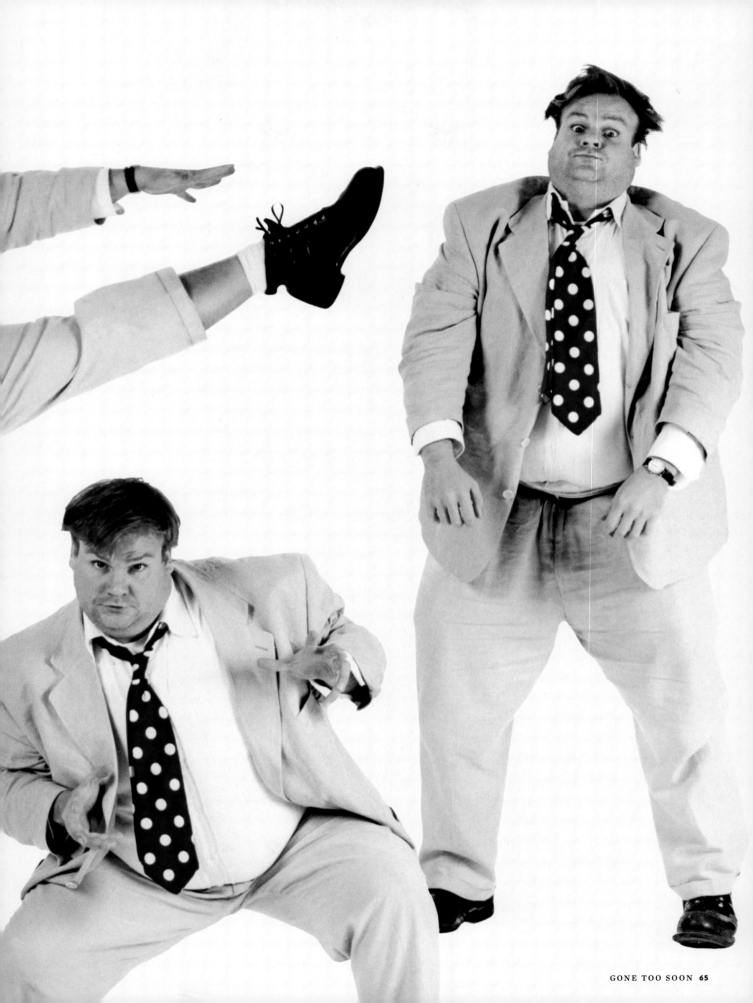

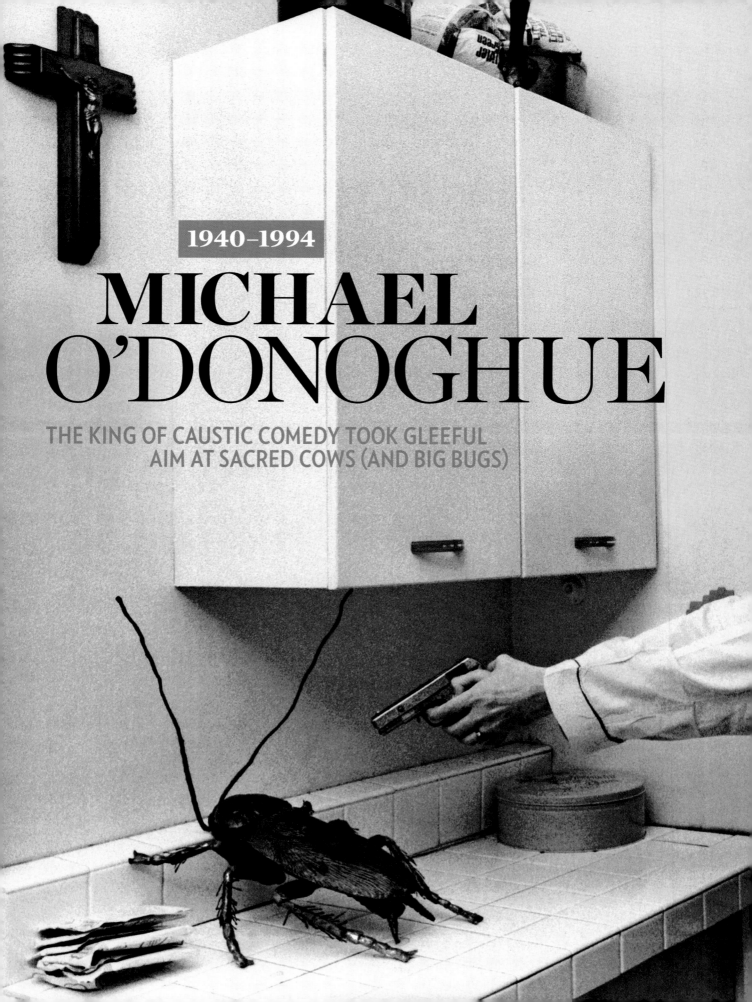

1940–1994

MICHAEL O'DONOGHUE

THE KING OF CAUSTIC COMEDY TOOK GLEEFUL AIM AT SACRED COWS (AND BIG BUGS)

He appeared in the first sketch of the first episode of *Saturday Night Live*, on Oct 11, 1975, as a language instructor trying to teach English to John Belushi. The phrase Michael O'Donoghue, who wrote the skit, was trying to impart said much about *SNL* in general and about O'Donoghue in particular:

O'Donoghue: "Repeat after me. 'I would like . . .'" Belushi: "I would like . . ."
O'Donoghue: "To feed your fingertips . . ."
Belushi: "To feed your feen-ger teeps . . ."
O'Donoghue: "To the wolverines."
Belushi: "To duh wol-verines."

Clearly, this was not *Laugh-In* or *Carol Burnett*, and O'Donoghue was not Mr. Rogers (though one of his *SNL* personas, Mr. Mike, whose *Least-Loved Bedtime Stories* frequently ended badly for those involved, was clearly Mr. Rogers's malevolent twin). O'Donoghue's mordant, sometimes shocking humor didn't appeal to everyone, but it did appeal to a vast swath of Baby Boomers who yearned for a little jalapeno, or even some bitter herbs, in the bland TV dinner they'd been served since childhood. His humor helped shape the *National Lampoon* magazine, and he was cowinner of two writing Emmys for his work on *Saturday Night Live* in 1976 and 1977.

He could be droll, and he sometimes—okay, almost always—pushed the limits of good taste. "It's all very easy to laugh at yourself," he once said. "The difficult thing is learning to laugh at others." He remarked that "life is not for everybody" and claimed to be working on something called *The Dairy of Anne Frank*, "in which a plucky little Jewish girl hides from the Nazis in the attic with a herd of cows." "My humor is cruel if you accept *I Love Lucy* as the standard," he once said. "But life in America is pretty violent fare. I just think my humor is accurate reflection of my times. Nobody is painting Botticellis anymore."

O'Donoghue could also, when he wanted, play to a broader audience: He cowrote the screenplay for the Bill Murray Christmas hit *Scrooged* and scored a Top 10 country single with his song "(Single Bars and) Single Women," which became a hit for Dolly Parton.

He died of a brain hemorrhage, at 54, in 1994.

FREDDIE PRINZE

A ROCKET RIDE TO STARDOM HID A TALENTED COMEDIAN'S TROUBLED PSYCHE AND CRIES FOR HELP

In 1973 he was in high school. In 1974 he was starring on a hit NBC series, *Chico and the Man.* It all happened at warp speed, and it may have twisted Freddie Prinze.

Not that there hadn't been substantial turbulence already. The son of immigrants—his father was Hungarian and part Jewish, his mother Puerto Rican and Catholic—he grew up working-class in New York City and jokingly described himself as "Hungarican." "I fitted in nowhere," he told *Rolling Stone.* "I wasn't true spic, true Jew, true anything. I was a miserable fat schmuck kid with glasses and asthma." Like many comedians, he learned to use humor as a shield; when his parents sent him to a Lutheran school, he said, "all was confusing, until I found out I could crack up the priest doing Martin Luther."

His talent got him into Manhattan's High School of Performing Arts, which he attended when he wasn't too exhausted from performing, often for free, at late-night comedy clubs. In 1973 he appeared on a show with Jack Paar after a talent scout caught his act. That led to a spot on *The Tonight Show Starring Johnny Carson,* which led to a producer casting him in *Chico and the Man,* a sitcom about a crusty white auto mechanic and his wisecracking Chicano assistant. (When the sitcom became a huge hit, Chicanos—Americans of Mexican descent—protested the use of Prinze to portray one of their own. "If I can't play a Chicano because I'm Puerto Rican," Prinze observed, "then God's really gonna be mad when he finds out Charlton Heston played Moses."

But the jokes, as always, hid trouble. Friends would later recall that Prinze, as a child, could often be moody. He had, said his publicist, "fits of elation and fits of depression." Overwhelmed by the demands of his new life and by his own troubled psyche, he wallowed in drugs, and an impulsive marriage imploded, painfully, after about a year. Distraught, he told friends he was going to shoot himself; few believed him. On Jan. 28, 1977, in front of his manager, he did. "He was in turmoil, he was suffering such pain," his friend, entertainer Tony Orlando, said at his funeral. "And yet his audience never knew."

He was 22.

JOHN RITTER

A BELOVED ACTOR, A BEAUTIFUL DAY— AND, WITHOUT WARNING, TRAGEDY

Fresh from a workout with his trainer, John Ritter arrived on the Disney lot at 11:30 a.m., bumped into actor Howard Alonzo and gave him a bear hug. The star of the ABC sitcom *8 Simple Rules for Dating My Teenage Daughter,* Ritter was in a great mood: It was his daughter Stella's first week in preschool, and he was getting a kick out of being her personal chauffeur.

On the set he said he felt tired. He went to his dressing room to rest but began sweating and vomiting. A studio doctor told him to go the hospital immediately.

The situation got worse, quickly: Doctors detected a tear in his main artery and sent him to surgery. He died on the operating table shortly after 10 p.m.

His death shocked fans and devastated many in Hollywood. By all accounts, Ritter, 54, was as personable and funny offscreen as the characters he played on TV—thanks, perhaps, to the fact that he himself was the son of two modest, down-home stars: Tex Ritter, a B-western personality and country singer, and Dorothy Fay, at one time the Grand Ole Opry's official greeter. "When I saw his picture on the TV screen with two dates on it," said actress Markie Post, a friend, "it was like a kick in the gut."

"He was a ridiculously proud father," said Joyce DeWitt, one of Ritter's costars on *Three's Company,* the '70s sitcom that made them both famous. (In addition to Stella, with second wife Amy Yasbeck, Ritter had three children with his first wife, actress Nancy Morgan.) His marriage to Yasbeck was "magical," said Post. "They were like the perfect comedy team with love mixed in."

Friends say he realized his life had been blessed in many ways and was grateful. "John was never happier than the day he died," said one. "Everything was perfect."

MUSICIANS

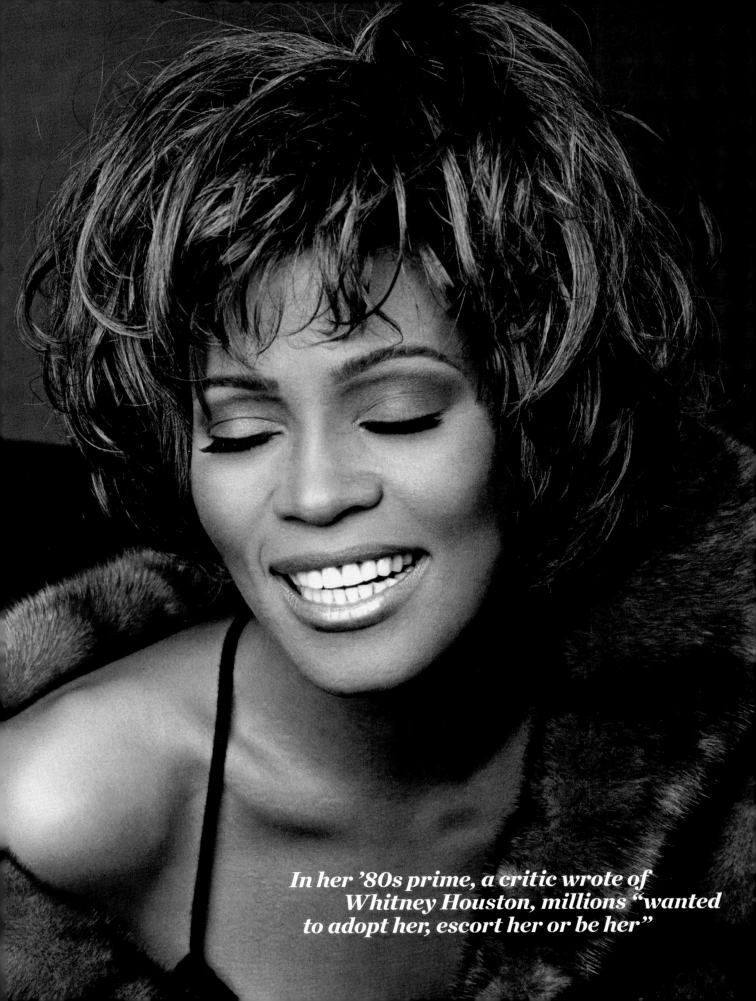

In her '80s prime, a critic wrote of Whitney Houston, millions "wanted to adopt her, escort her or be her"

WHITNEY HOUSTON

A POP SUPERNOVA WITH CHARISMA TO BURN

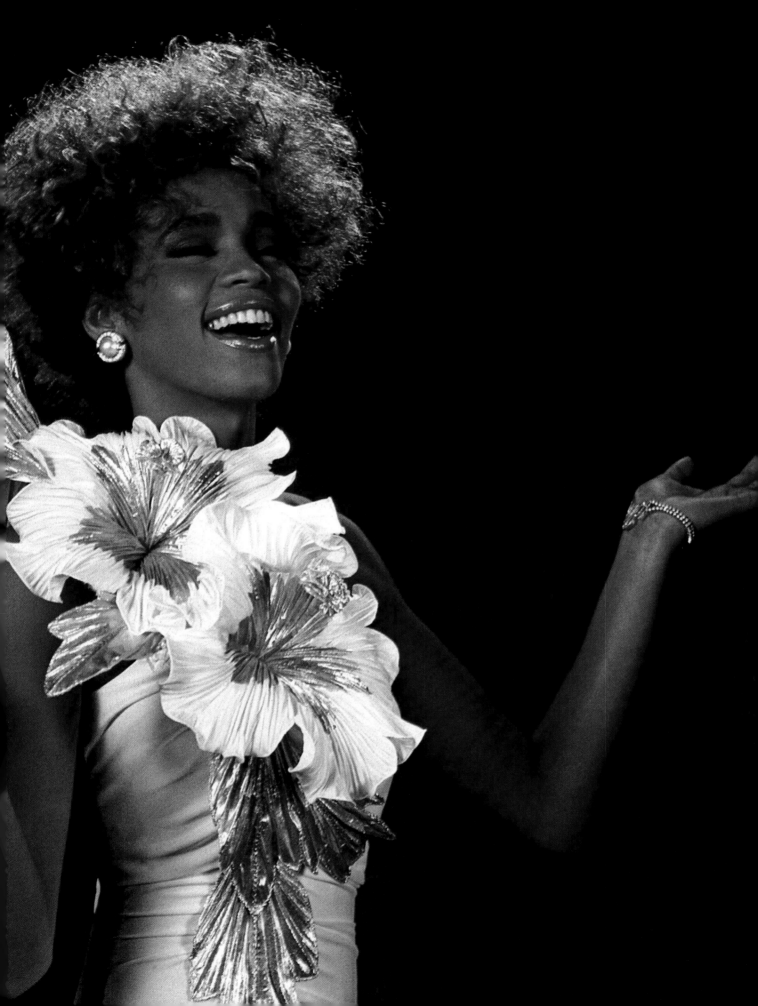

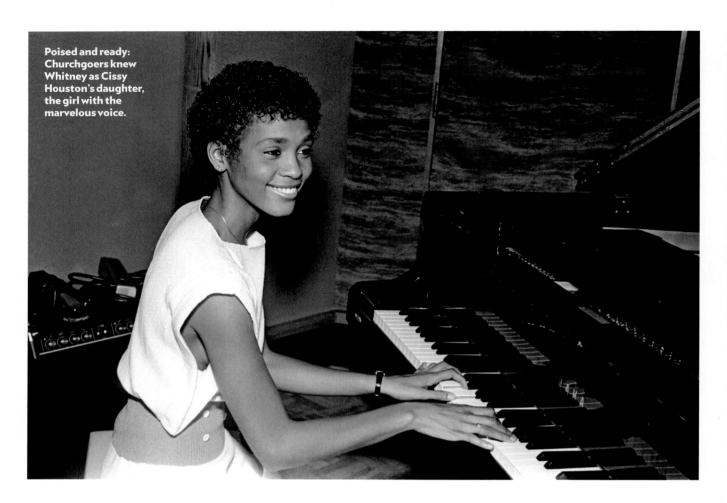

"She knows the truth." Houston once said of daughter Bobbi Kristina. "She knows what happens in this household."

When Whitney Houston was 19 and an unknown, Clive Davis, her producer and mentor, made an outlandish claim: "There was Lena Horne," he said. "There is Dionne Warwick. But if the mantle is to pass to somebody... who's elegant, who's sensuous... who's got an incredible range of talent... it will be Whitney Houston."

Good call. Houston would have been a star in any age, but as the total made-for-MTV package—amazing voice, dazzling smile, light-up-your-life energy—in a world newly gone crazy for music videos, she probably went further, faster than any pop star in history. Her record seven No. 1 hits in a row—beginning in 1985 with "Saving All My Love for You" and including "Didn't We Almost Have It All" and "I Will Always Love You"—beat the Beatles; her first album, Whitney Houston, became, at the time, the bestselling debut by a female. In her '80s glory, a critic wrote, everyone wanted to "adopt her, escort her or be her."

But even then, a Houston relative said after her death, "She was never what you all thought she was. She could swear like a sailor, and they were always worried she was going to drop the F-word in public and it would make people not like her." Sadly, the world

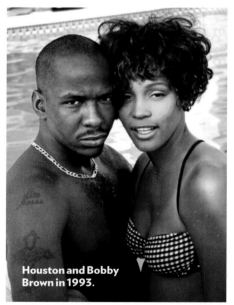

Houston and Bobby Brown in 1993.

eventually saw that side of Houston too, during her wild 14-year marriage to Bobby Brown and her long battle with drug addiction. On Feb. 11, hours before the Grammys telecast, Houston drowned in her bathtub at the Beverly Hills Hilton. A coroner's report later showed evidence of cocaine use and 12 different medications in her blood.

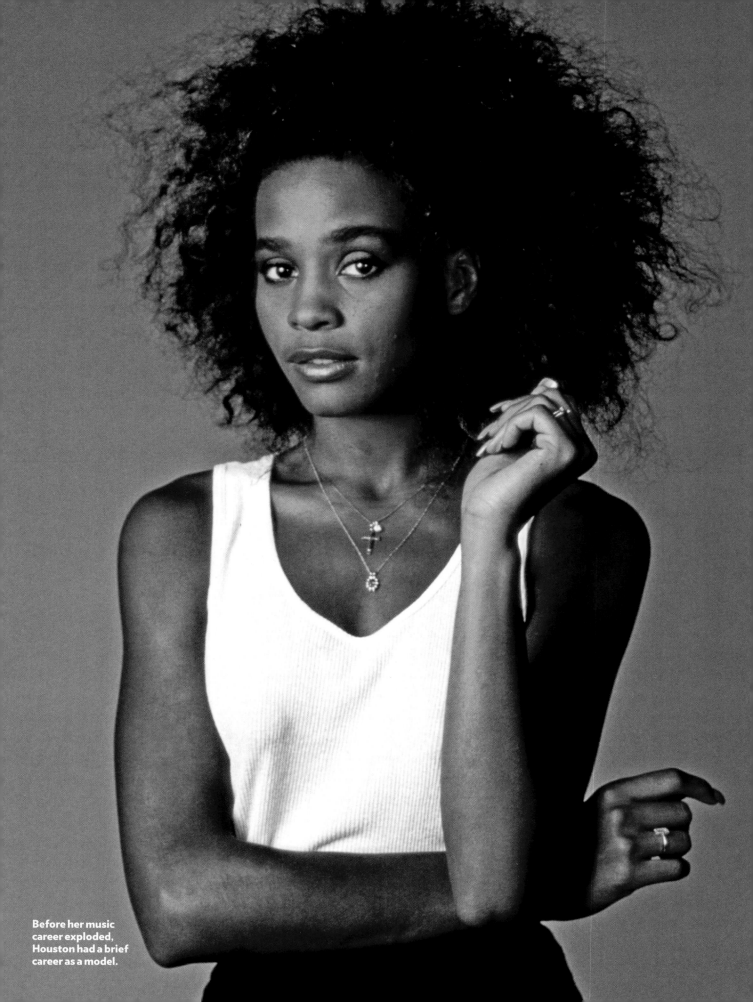

Before her music career exploded, Houston had a brief career as a model.

"She was sexy like Madonna, but never vulgar," said a friend. "Her sweetness came through"

1971–1995

SELENA

AN ANGRY EMPLOYEE, A GUN, AND HEARTBREAK

Selena had touched them in life; now, as many as 50,000 mourners, from as far away as Canada and Guatemala, converged on Corpus Christi, Texas, to pay their respects. Their sense of loss was overwhelming. At one point a rumor swept the crowd that Selena Quintanilla-Perez, 23, the Queen of Tejano music, was still alive and that her coffin, surrounded by white long-stemmed roses, was empty. Finally, her family ordered the coffin opened briefly to confirm the unacceptable truth. There she lay, her lips and long nails done in blood-red, wearing a purple gown.

The bizarre tragedy unfolded two days before, on March 31, 1995, when Selena went to a local Days Inn to confront Yolanda Saldivar, 34, the former president of her fan club. Suspected by Selena and her family of embezzling funds, Saldivar was on the verge of being fired and knew it. Soon after Selena arrived, Saldivar shot her once in the back with a .38 revolver. The singer staggered to the lobby before collapsing and being rushed to a hospital. Saldivar kept SWAT teams at bay for nearly 10 hours as she sat in a pickup truck with a gun to her head, threatening suicide, before finally surrendering.

For Selena's family, who knew Saldivar well, the rush of events had a surreal quality. "The ultimate sorrow a human can feel is when someone dies," said her father, Abraham Quintanilla Jr. "I felt like this was all a dream."

For Latin music enthusiasts, the most apt comparison was with the death of John Lennon. Selena was vastly talented and deeply adored. In recent years she had played to audiences of up to 80,000; her newest album, *Amor Prohibido*, had sold more than 500,000 copies and received a Grammy nomination. Said one critic: "We will never know how far she could have gone."

Saldivar, a loner, had founded Selena's fan club and become close to the star; Saldivar's home, said an acquaintance, was a virtual shrine to the singer. Said Esmeralda Garza, the fan club's former secretary: "She probably couldn't accept the fact that she wasn't going to be around Selena anymore."

At her trial, Saldivar claimed the shooting was accidental. She was convicted of first-degree murder and sentenced to life in prison.

1967–1994

KURT COBAIN

HERE WE ARE NOW, ENTERTAIN US: A PUNK ROCKER RECOILS FROM THE STORM HE HELPED CREATE

It could have been the pain in his stomach. Or the drugs. Or the crazy life he was leading. Most likely, it was all three.

On April 5, 1994, Kurt Cobain, 27, the "Smells Like Teen Spirit" singer and reluctant grunge icon, walked into the garage apartment of his Seattle home, placed his driver's license beside him—so there would be no question of identification—pointed a shotgun at himself and pulled the trigger. He had recently fled an L.A. drug-treatment center; his wife, musician Courtney Love, had been looking for him for days. A suicide note he left alluded to chronic, undiagnosed pains in his "burning, nauseous" stomach that had haunted him for years; heroin, he once said, was the only drug he had found that eased the pain. The shotgun blast was so fearsome that authorities had to use fingerprints to identify the body; Love later clipped and kept a lock of his blond hair.

Cobain, who grew up in the depressed logging town of Aberdeen, Wash., came by his alienation honestly. Two of his father's uncles had committed suicide in the '70s, and, said cousin Bev Cobain, a nurse, alcoholism and dysfunctional marriages plagued the clan. "I don't think there was much functional stuff going on in the whole family," she noted. A bright, hyperactive kid who had been prescribed Ritalin, Cobain "changed completely," said his mom, Wendy O'Connor, after his parents divorced when he was 8: "It just destroyed his life." He expressed his anger by drawing caricatures of his parents on his bedroom walls, labeling them "Dad sucks" and "Mom sucks."

What followed was a model rebellion: Uncontrollable, he was shuttled between his parents and relatives. At school he dyed his hair wild colors and taunted the jocks. "He stood out," said a friend, "like a turd in a punch bowl." He fell in love with punk music and picked up a guitar.

Despite having won two state art scholarships, Cobain decided to skip college for what he later called the "Aberdeen fantasy version of being a punk rocker." Days were spent drinking and drugging; he worked for a while as a janitor at his old high school and at one point lived under a bridge. He formed a band, Nirvana, and it began getting noticed. "You always went away hearing Kurt's voice," said Jack Endino, who later produced Nirvana's first album.

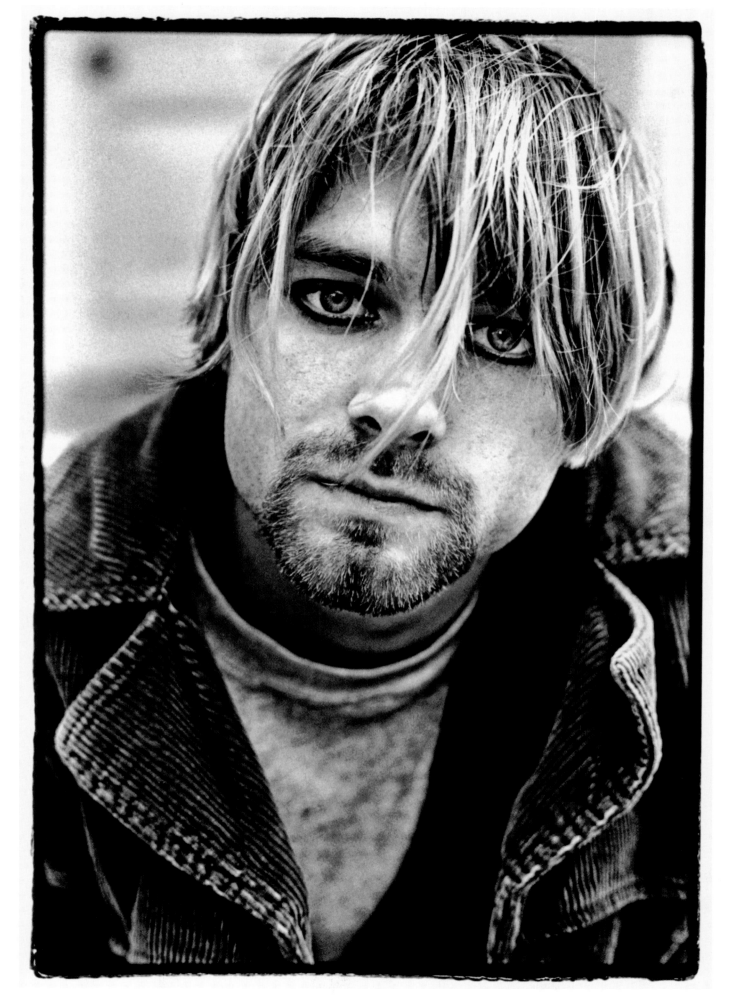

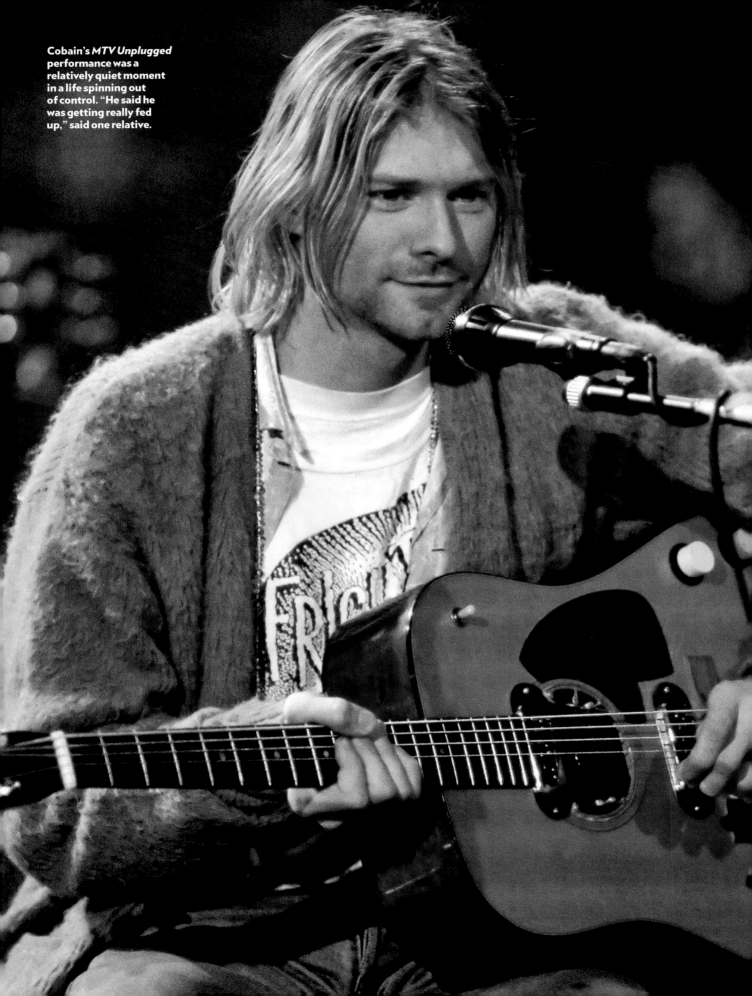

Cobain's *MTV Unplugged* performance was a relatively quiet moment in a life spinning out of control. "He said he was getting really fed up," said one relative.

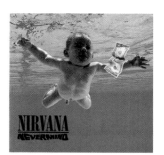

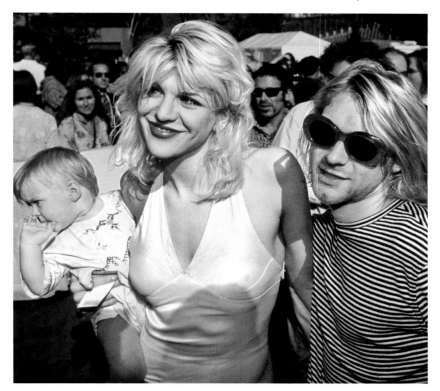

"We bonded over pharmaceuticals," said wife Courtney Love (below, with Cobain and their daughter Frances Bean in 1993). Left: Nirvana's *Nevermind* album, with its iconic photo, has sold more than 30 million copies.

From Aberdeen, Nirvana moved on to Olympia and Seattle. Geffen Records signed the group in 1991; friends said Cobain never recovered from the shock when their breakthrough album, *Nevermind*, sold more than 10 million copies worldwide and gave Gen X an anthem, "Smells Like Teen Spirit." In front of cameras, he mugged with a madhouse gleam, acting as if only a demented world would declare him "the voice of a generation." Which, of course, only fed the legend. A saving grace was that he could, at times, laugh at the absurdity of it all. "Teenage angst has paid off well," he noted in one song, "Serve the Servants."

Cobain married Love in 1992, and the two had a daughter, Frances Bean, whom Kurt adored. But even his joy in fatherhood couldn't counter his demons. Why suicide? "It's complicated and hard to figure out," said Endino. "Basically, he was just a nice guy who didn't like fame. He was not your typical rock-star exhibitionist. . . . He was happy to be making music and to get the hell out of Aberdeen. But how many rock icons blow themselves away at the height of their fame?"

KAREN CARPENTER

THE DEATH OF A VIBRANT YOUNG SINGER—AND ITS SURPRISING CAUSE—SHOCK THE CULTURE

At one point, Carpenter (in 1981) weighed as little as 85 lbs.

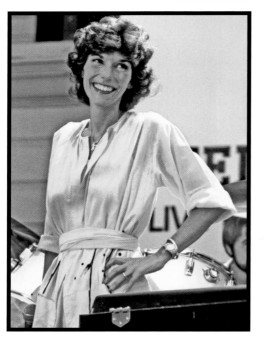

She did needlepoint, collected Mickey Mouse memorabilia and seldom drank anything harder than iced tea. Her death stunned the country, and not only because of her youth and squeaky-clean image: When Karen Carpenter, half of the 80-million-record-selling brother-sister duo the Carpenters, died of heart failure at 32 in 1983, it was the first time many Americans had ever heard of what, until then, had been a little-understood disease as mysterious as it was potentially deadly: anorexia nervosa.

Despite immense success—the Carpenters' hits "Close to You" and "We've Only Just Begun" were ubiquitous in the '70s—Karen was unhappy with what a friend called her "pear-shaped" figure and tried hard to please her parents and her brother Richard, whom she worshipped. Publicly, she was, like the duo's sweetly optimistic music, always upbeat; a "magical person," in the words of composer Burt Bacharach. But as a doctor at UCLA's Eating Disorders Clinic noted at the time, "It's common for [anorexics] to be sweet.... Many keep their emotions inside. They take care of other people, but they don't take care of themselves."

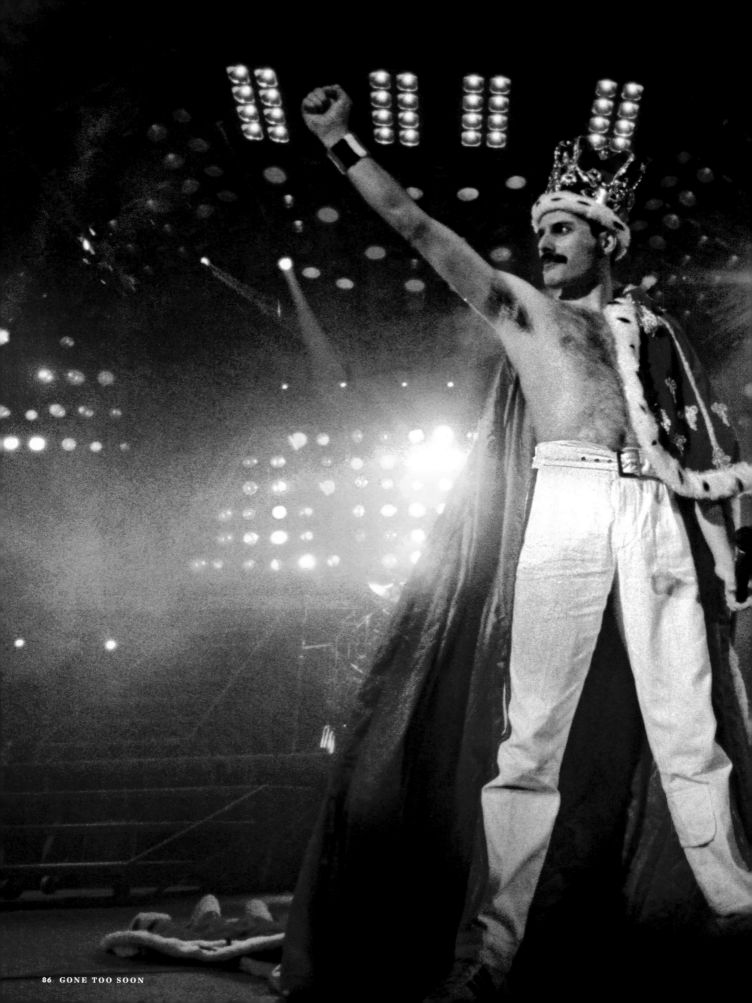

Showmanship, thy name was Freddie. The lead singer and a songwriter for the supergroup Queen, Freddie Mercury mixed rock, opera, bombast and bravura to create genre-defying hits like "Bohemian Rhapsody"—which used more than 50 chords—and the now-ubiquitous sports anthem "We Are the Champions." Onstage, spandexed or shirtless, he delighted in the grand gesture and dramatic tableaux; Mercury owned a 20-plus-room mansion in London's Kensington district, but his public persona lived, full tilt and unapologetic, at the corner of rock and rococo.

Before he was Freddie Mercury, he was Farrokh Bulsara, just a kid from Zanzibar (now Tanzania), where his father worked for the British Colonial Office. The family moved to England in the '60s ,and Mercury joined guitarist Brian May, bassist John Deacon and drummer Robert Taylor to form Queen in the early '70s. From the start, the band seemed to pursue both its music and stage show with go-for-baroque glee. "Prancing down multilayered catwalks in a sequinned, skintight jumpsuit and ballet slippers, preening his way through a myriad of costume changes and singing in his majestic, slightly frayed tenor voice, Mercury always matched up to the demands of projecting the group's music and image to the four corners of the world's biggest auditoriums," wrote a *London Times* reporter. Or, as another critic put it, "Freddie could be stunningly tacky, but he'd do it with class and style."

In 1989 Mercury dropped from sight, and rumors began to circulate that he had AIDS. But the reports of his ill health were vehemently denied. Then, on Nov. 23, 1991, the 45-year-old singer released a statement saying he had the disease but "felt it correct to keep this information private to date in order to protect the privacy of those around me. However, the time has now come for my friends and fans around the world to know the truth, and I hope that everyone will join me, my doctors and all those worldwide in the fight against this terrible disease." He died the next day, of bronchial pneumonia.

"Of all the more theatrical performers, Freddie took it further than the rest," David Bowie told *Rolling Stone*. "And of course, I always admired a man who wears tights."

1946–1991

FREDDIE MERCURY

MIXING SPANDEX AND SPECTACLE? HE WAS THE CHAMPION OF THE WORLD

AMY WINEHOUSE

HER TALENT WAS UNDENIABLE. SO WAS HER BATTLE WITH ADDICTION

A '60s throwback with a soulful voice, Amy Winehouse exploded with her multi-Grammy-winning 2006 album *Back to Black* and its autobiographical megahit "Rehab." After that, alas, she mostly made headlines, relentlessly, for self-destruction. Her brief, heroin-and-violence-filled marriage to Blake Fielder-Civil fed tabloids for months; ditto her varying problems with alcohol, marijuana and, reportedly, crack cocaine; her revolving-door relationship with rehab; and spurts of violence (at least eight incidents during a 20-month stretch in 2008-2009, including alledgedly attacking fans, bar patrons and her own bodyguard). A 2011 comeback faltered when, during her first concert, in Serbia, she stumbled onstage and slurred lyrics. Said her mom, Janis, "I've steeled myself to ask her what ground she wants to be buried in, which cemetery."

Winehouse, 27, was found dead in her London apartment on July 23, 2011; a coroner cited alcohol poisoning—tests showed about five times the legal driving limit—as the cause. Wrote her friend, comedian Russel Brand, himself a recovering addict: "When you love someone who suffers from the disease of addiction you await the phone call. The sincere hope is that the call will be from the addict themselves, telling you they've had enough . . . You fear the other call, the sad nocturnal chime from a friend or relative telling you it's too late, she's gone."

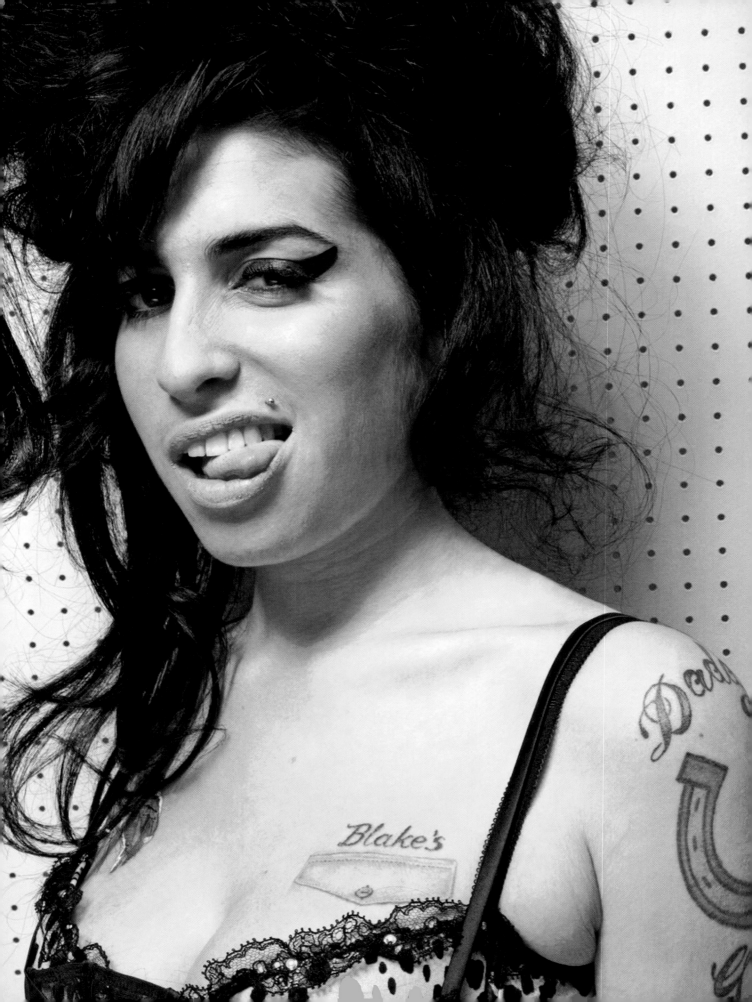

TUPAC SHAKUR & NOTORIOUS B.I.G.

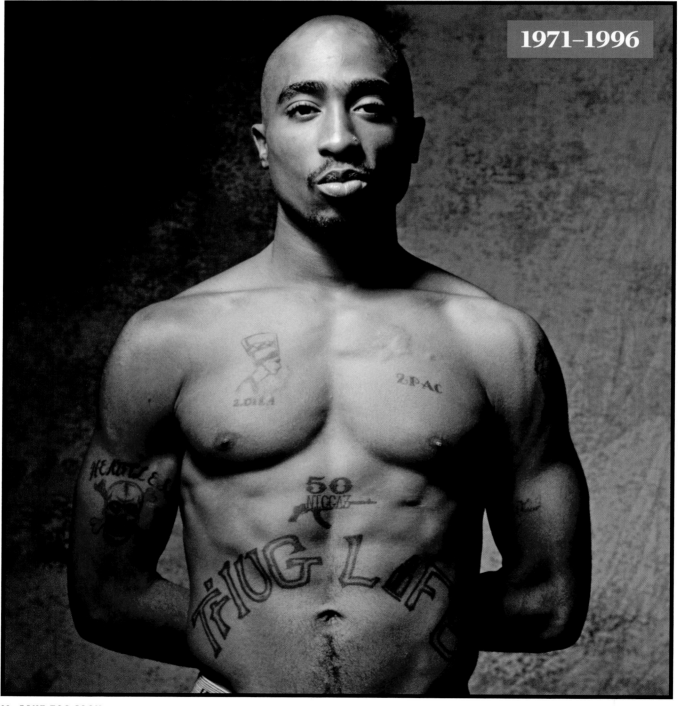

1971–1996

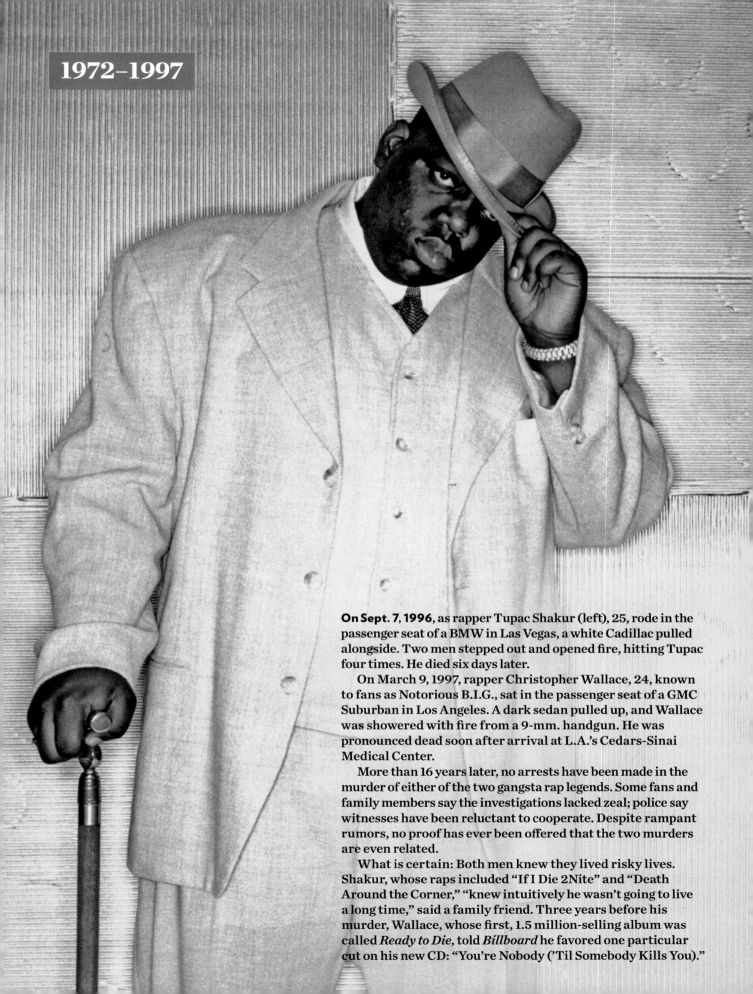

On Sept. 7, 1996, as rapper Tupac Shakur (left), 25, rode in the passenger seat of a BMW in Las Vegas, a white Cadillac pulled alongside. Two men stepped out and opened fire, hitting Tupac four times. He died six days later.

On March 9, 1997, rapper Christopher Wallace, 24, known to fans as Notorious B.I.G., sat in the passenger seat of a GMC Suburban in Los Angeles. A dark sedan pulled up, and Wallace was showered with fire from a 9-mm. handgun. He was pronounced dead soon after arrival at L.A.'s Cedars-Sinai Medical Center.

More than 16 years later, no arrests have been made in the murder of either of the two gangsta rap legends. Some fans and family members say the investigations lacked zeal; police say witnesses have been reluctant to cooperate. Despite rampant rumors, no proof has ever been offered that the two murders are even related.

What is certain: Both men knew they lived risky lives. Shakur, whose raps included "If I Die 2Nite" and "Death Around the Corner," "knew intuitively he wasn't going to live a long time," said a family friend. Three years before his murder, Wallace, whose first, 1.5 million-selling album was called *Ready to Die*, told *Billboard* he favored one particular cut on his new CD: "You're Nobody ('Til Somebody Kills You)."

ANDY GIBB

PUPPY-DOG CHARM AND, IN THE END, A HEARTBREAKING HABIT

Australian Andy Gibb had just moved to America when his first single, "I Just Want to Be Your Everything," hit No. 1 on U.S. pop charts in 1977. His second single, "(Love is) Thicker than Water," did the same. Ditto his third, "Shadow Dancing." No solo performer had ever done that. It was a breathtaking start: Andy Gibb was 19.

That level of cyclonic celebrity would have been difficult for anyone to handle; for Gibb, baby brother of Barry, Robin and Maurice Gibb of the monster group the Bee Gees, it was impossible. "Superstars usually have a tough hide from having doors slammed in their face and hustling," said a former president of Andy's record label. "Andy never built up those layers because he never had to. Andy grew older, but he never grew up. He was frozen in time at about 17." Performing, he radiated boyish charm; offstage, he was haunted by self-doubt. Said his former agent: "Sometimes I'd say, 'Andy, look in the mirror. You've got everything—good looks, talent. Women love you.' Men liked him too. But when he looked in the mirror, you always had the feeling he didn't see anything."

Gibb filled the emptiness with cocaine, which led to a numbing litany of Troubled Andy stories. He was hired to cohost the dance show *Solid Gold* and appear in the musicals *Pirates of Penzance* and *Joseph and the Amazing Technicolor Dreamcoat*—then fired from each for not showing up. "We'd lose him over long weekends," recalled *Dreamcoat* producer Zev Bufman. "He'd come back Tuesday, and he'd look beat. He was like a little puppy—so ashamed when he did something wrong." At 23, Gibb fell madly in love with, then split from, Victoria Principal, 31. "I just fell apart," he said later. "I started to do cocaine around the clock—about $1,000 a day. . . . I really think the major reason I fell from stardom was my affair with Victoria." She saw it differently. "I did everything I could," Principal said. "But then I told him he would have to choose between me and his problem."

Gibb finally committed himself to rehab and, by 1988, was living at his brother Robin's Oxfordshire estate and planning a comeback. In March he checked into a hospital, complaining of stomach pains; three days later he died of what doctors determined was an "inflammation of the heart." Although enlargement of the heart is a common side effect of long-term cocaine use, the hospital said a virus might have been the cause.

In Australia, at 19, Gibb had married an 18-year-old receptionist, Kim Reeder, who gave birth to a daughter, Peta, before the marriage fell apart. Although Andy never saw either of them again after 1980, he phoned regularly. Why? "I think," Kim said after hearing of his death, "we were the only touch with reality he ever had."

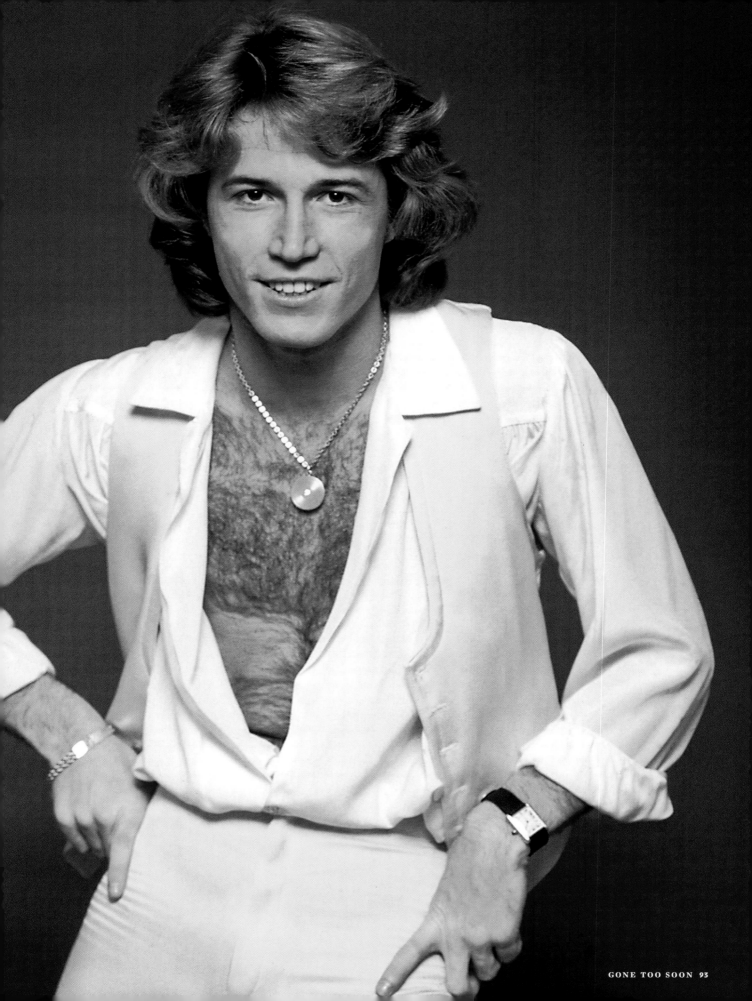

LUTHER VANDROSS

WHEN THE MAN WITH THE BEDROOM VOICE DIED, A LITTLE BIT OF LOVE WENT OUT OF THE WORLD

Like many of Luther Vandross's close friends, Patti LaBelle never lost hope that the singer famous for his swoon-worthy slow jams would recover from the stroke he suffered in 2003. "I just thought he would be okay," she said. But as time wore on and Vandross's condition failed to significantly improve, "I saw him and I said to myself so many times, 'He'll never sing again, but I'm not gonna let anybody know that,'" she said. "I was keeping hope alive with everybody, I was praying for this miracle."

Sadly, a miraculous recovery eluded Vandross, who died at 54 during physical therapy. He had been dramatically weakened by the stroke, and moments of joking and singing with his loved ones had become sporadic. Still, his death shocked even his inner circle. "There was no turn for the worse," said his business manager, who had visited the singer a week before.

Vandross's only public appearances since the stroke had been videotaped: once with Oprah and once for the Grammy Awards in 2004, to accept his Song of the Year trophy for "Dance with My Father." "He was such a man of dignity," said his friend and frequent songwriting partner Richard Marx, who cowrote "Dance." "The times that I went to see him [after the stroke], my thought was, 'If he really knew what was happening here, he'd be miserable.'" But he did know and was brave.

Gracious, witty and impeccably style-conscious—he rarely took to the stage in anything but a tuxedo and showered his elderly mother, Mary Ida, with designer clothes—Vandross was "just the nicest guy and always sweet and funny as hell," said Kenneth "Babyface" Edmonds. In private he could display a biting wit that was "hilariously caustic," said Marx. "He was one of those guys who, the angrier he got, the more articulate he got. He was razor-sharp."

For his fans, it was the seductive voice—one that "puts you in a space you can't help traveling through," said singer Alicia Keys—that helped Vandross sell more than 30 million albums and win eight Grammys. Said LaBelle: "He had the one and only voice like that in the world. So many people had babies because of Luther Vandross. He made you just want to make love and be happy."

His own life had been marked by sorrow. The youngest of four kids reared in New York City, he lost his father to diabetes when he was 8. Vandross himself battled diabetes, hypertension and obesity—his weight fluctuated from 180 to 320 lbs.—and all three of his siblings died from various health complications. His mother, Mary Ida, "buried all her children," said Nat Adderley Jr., Vandross's longtime musical director. "She outlived all four of them. I'm so sad for her."

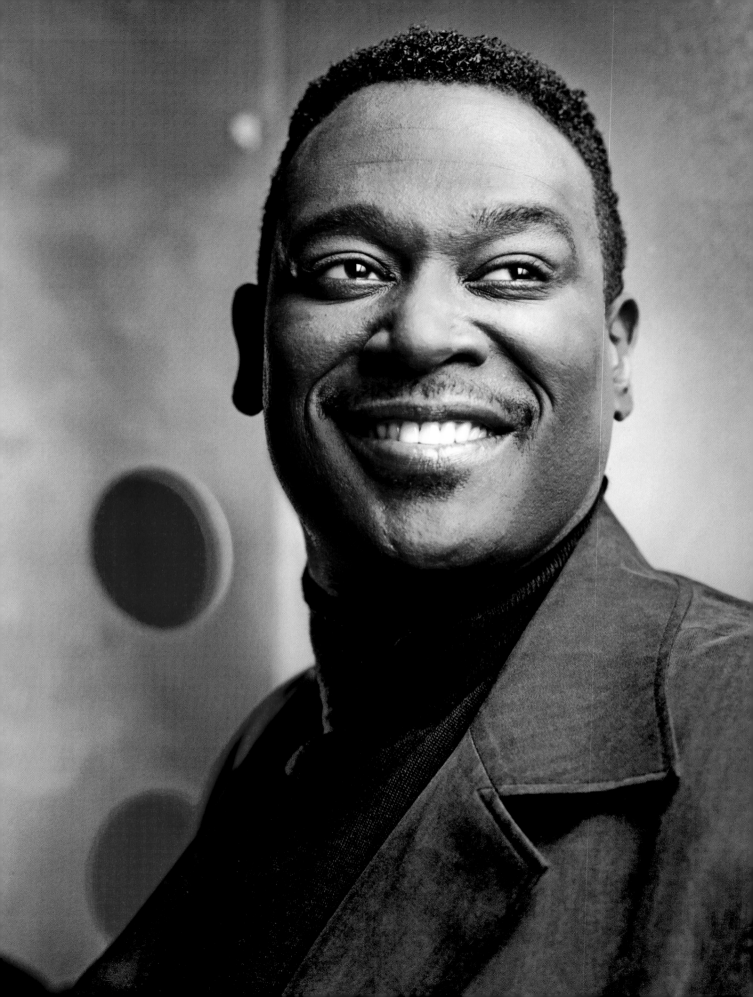

1951–2001

JOEY RAMONE

BENEATH THE HAIR AND LEATHER
LURKED A PUNK PIONEER WITH A SENSE
OF HUMOR AND A HEART OF GOLD

Joey Ramone was loved, and he died the way few rock stars do: not in a plane crash, not in the Chelsea Hotel, but surrounded by his family, who played his favorite bedside song, "In a Little While," a gift from U2's Bono. The tender ballad seemed an apt choice under the circumstances, yet it was also an anomalous one for a punk rocker who once sang, "All the girls are in love with me/ I'm a teenage lobotomy."

Joey Ramone—born Jeffrey Hyman—was a musical rebel who, with three friends from his Queens neighborhood, John Cummings, Douglas (Dee Dee) Colvin and Tommy Erdelyi, formed the Ramones in 1974 and rattled rock music with three-chord sonic blasts and tongue-in-cheek lyrics that riffed on teen sex, suburban malaise and various addictions. With Joey as lead singer on tunes like "I Wanna Be Sedated" and "Now I Wanna Sniff Some Glue," the Ramones "would play 20 short songs in 17 minutes without stopping," recalled Hilly Kristal, owner of New York City's underground rock mecca CBGB.

"No one was calling it punk rock at the time," added Kristal, but the Ramones' 1976 debut album and their British tour that year inspired the rise of even spikier bands, including the Sex Pistols and the Clash. The Ramones disbanded in 1996, after Joey was diagnosed with cancer. Until shortly before he died, at 49, "you wouldn't have known he was sick," said a friend. At over six feet, "he was always a big guy, but his face was so delicate. That's how he looked at the end."

DJ AM

SURVIVING A NEAR-FATAL JET CRASH, HAUNTED BY ITS AFTERMATH

Eleven months earlier, Adam Goldstein had jumped through flames to survive a Learjet crash; two of his friends didn't make it. That experience left Goldstein—better known as DJ AM—covered in severe burns and keenly aware of how lucky he was. "I live my life to the fullest," he said afterward, "[because] I don't know how much longer I'm going to be around."

Weeks before the anniversary of the crash, Goldstein, 36, was found dead in his New York City apartment. Having ended his relationship with his girlfriend earlier in the week, he tweeted an ominous Grandmaster Flash lyric on Aug. 25: "New York, New York, big city of dreams/And everything in New York ain't always what it seems." The police found the recovering drug addict (in July he said he'd been sober for more than 11 years) in bed with a half-used bag of crack cocaine and two pipes three days later. Prescription pills lay nearby. Friends say Goldstein was not depressed about his breakup, but that the survivor's guilt and post-traumatic stress disorder he battled as a result of the crash may have contributed to a relapse. "His death," said one friend, "was the direct result of the plane crash."

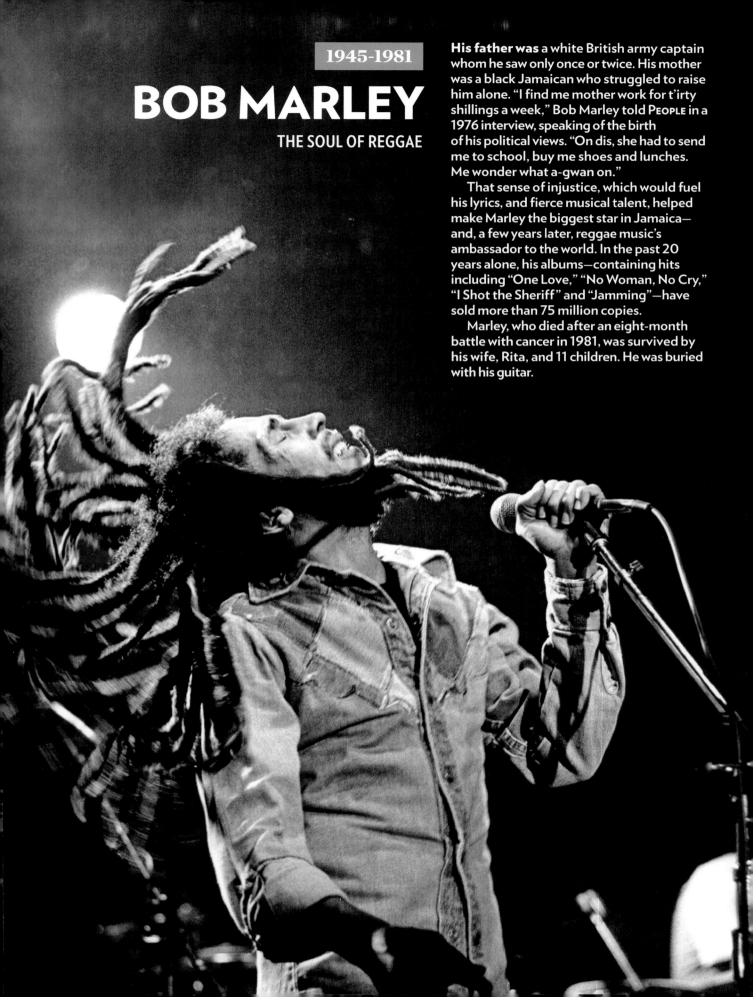

1945-1981

BOB MARLEY

THE SOUL OF REGGAE

His father was a white British army captain whom he saw only once or twice. His mother was a black Jamaican who struggled to raise him alone. "I find me mother work for t'irty shillings a week," Bob Marley told PEOPLE in a 1976 interview, speaking of the birth of his political views. "On dis, she had to send me to school, buy me shoes and lunches. Me wonder what a-gwan on."

That sense of injustice, which would fuel his lyrics, and fierce musical talent, helped make Marley the biggest star in Jamaica—and, a few years later, reggae music's ambassador to the world. In the past 20 years alone, his albums—containing hits including "One Love," "No Woman, No Cry," "I Shot the Sheriff" and "Jamming"—have sold more than 75 million copies.

Marley, who died after an eight-month battle with cancer in 1981, was survived by his wife, Rita, and 11 children. He was buried with his guitar.

JOHN DENVER

AN UPBEAT TROUBADOUR SANG OF A MYTHICAL MOUNTAIN WORLD AND SOMETIMES STRUGGLED IN THE REAL ONE

He was something of a paradox: His folksy lyrics sang of blue skies and quiet mountain streams; in real life, he had been through two divorces, admitted to infidelities and had DWI problems. Some critics found his music saccharine; 13 platinum albums, including *Back Home Again* and *Rocky Mountain High,* and nearly 20 TV specials made clear he touched millions. "Some of my songs are about very simple things," he said. "But those simple things are meaningful to me and have obviously meant something to people all over the world, even if it's in a karaoke bar."

Denver, 53, had taken up flying in part to heal a fractious relationship with his father, a test pilot. "It was his approval I most wanted," Denver said. Highly experienced, he nonetheless ran into trouble while flying near Monterey, Calif. "He banked to one side, with the right wing down, the left wing up," said a witness. "I thought he was a stunt pilot. Then he hit the water." Investigators later determined that Denver, insufficiently familiar with his new airplane, probably lost control while trying to solve a fuel problem.

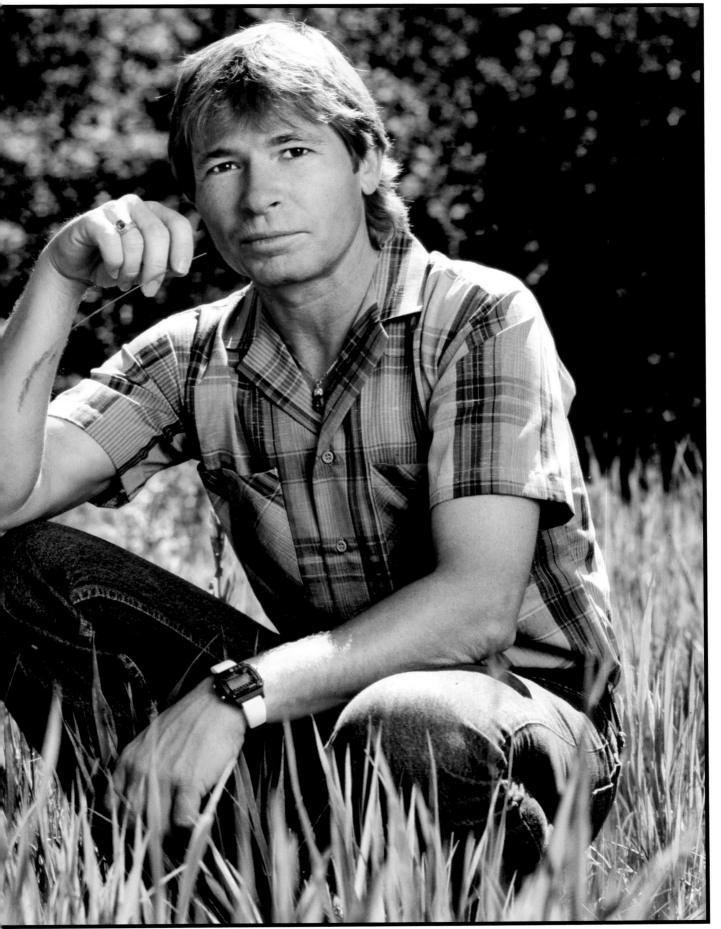

STEVIE RAY VAUGHAN

A BEAUTIFUL BLUESMAN WHO DID TEXAS PROUD

Blues guitar demigod Stevie Ray Vaughan played, sang, looked and lived the part. Raised in Dallas by blue-collar parents—his dad worked at an asbestos plant; his mom was a secretary at a cement factory—Vaughan dropped out of high school at 17 and began haunting Austin clubs, where his tar-paper voice and bandito hat became as familiar as his physics-defying fretwork. He became a guitarist other guitarists talked about; a videotape sent to Mick Jagger landed him an early New York club date and more exposure. Five albums, including the Grammy-winning *In Step*, followed.

But he was at his best playing live. At the Alpine Valley Music Theater near East Troy, Wis., on Aug. 27, 1990, Vaughan joined fellow bluesmen Eric Clapton, Buddy Guy, Robert Cray and Vaughan's older brother Jimmie for a blistering 20-minute version of "Sweet Home Chicago" to close the show. "It was one of the most incredible sets I ever heard Stevie play," Guy said later. "I had goose bumps."

Afterward Vaughan, 35, boarded a helicopter for the short flight back to Chicago. Moments later all five people on board died in what an aviation official called "a high-energy, high-velocity impact at a shallow angle." Authorities, noting that the craft had never gained sufficient altitude to get over surrounding hills, blamed pilot error.

Fans and friends, like Guy, were devastated. "Stevie is the best friend I've ever had," he said, "the best guitarist I've ever heard and the best person anyone will ever want to know."

ADAM YAUCH

BEHIND THE TONGUE-IN-CHEEK PERSONA, A GENTLE BEASTIE

The three-headed Jerry Lewises of rap, the Beastie Boys bottled a cultural moment with 1986's "(You Gotta) Fight for Your Right (to Party)" and, arguably, helped make the world safe for Eminem. But beneath the bluster lurked—good heavens!—some sincerity and seriousness: Cofounder Adam "MCA" Yauch, who once described the Beasties' partying persona as "a joke that just went too far," embraced Buddhism and cofounded the Milarepa Fund, which has organized benefit concerts and raised awareness about Tibetan issues. Yauch died, at 47, in May 2012 after a three-year battle with cancer. Fellow Beastie and lifelong friend Michael "Mike D" Diamond praised Yauch's faith, humor and humility: "The world is in need of many more like him."

1942–1995

JERRY GARCIA

EQUAL PARTS MUSICIAN AND MELLOW RINGMASTER, HE KEPT THE '60S ALIVE FOR 30 YEARS

Bearded and gray in his later years, a middle-aged man whose weight sometimes ballooned to 300 lbs., Jerry Garcia seemed the antithesis of a rock star. His idea of stagecraft was to stand rock-still and utter not a word to the multitudes who adored him. Yet he was a riveting performer, a benevolent Buddha whose face beamed with merriment and sometimes sorrow as notes cascaded from a custom guitar he seemed to play not with his hands but with his heart. "For me," he said, "it's always emotional."

On Aug. 9, 1995, Garcia's heart, 53 years old and ravaged by years of drug use and related health problems, gave out. The leader of the Grateful Dead was found during a routine bed check at a California drug treatment center, where he had checked in after a relapse into heroin addiction. An autopsy attributed his death not to drugs but to acute hardening of the arteries. "He created an entire subculture," said Chris Hillman, one the of the founders of the Byrds. "He had his roots in bluegrass and blues and folk, and he was able to take that and make this eclectic mixture of sounds, always delving into more experimental things. He was a true musical explorer."

A Pied Piper too: As the '60s hippie culture faded, Garcia, as much as anyone, continued to hold its rainbow banner aloft, lurching forward through the decades, laughing much of the way. "It's not just music, it's a religion," said San Francisco poet Hugh Romney, better known as the cosmic clown Wavy Gravy, of the Dead's music and movable-feast concerts. "The beauty of the Grateful Dead was their relationship with their fans. They just take this great big ball of love and bounce it out to the fans, and the fans bounce it back, and each time it just gets bigger." Garcia called the Deadheads—ardent, tie-dyed fans who followed the band from city to city, camping in stadium parking lots—"this time-frame's version of the archetypal American adventure. It used to be that you could run away and join the circus . . . or ride the freight trains."

That unique sense of community made Grateful Dead shows a cultural phenomenon: During the three years before Garcia's death, the band grossed $162 million. "When we get onstage," he once said, "we really want to be transformed from ordinary players to extraordinary ones, like forces of a larger consciousness. So maybe it's that seat-of-the-pants shamanism that keeps the audience coming back and keeps it fascinating for us too."

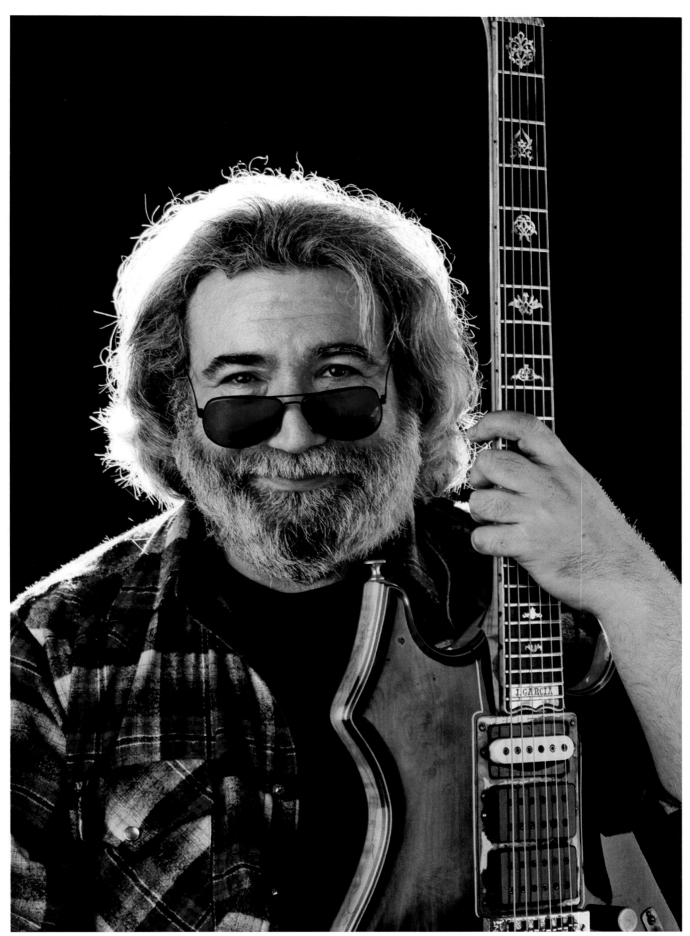

NEWSMAKERS

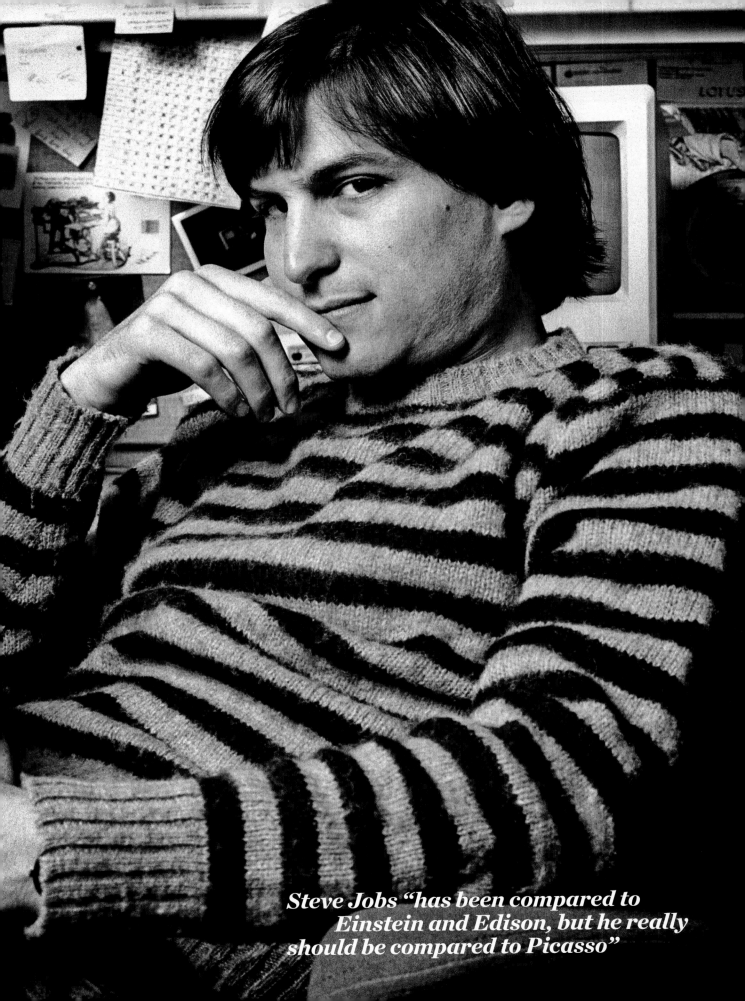

Steve Jobs "has been compared to Einstein and Edison, but he really should be compared to Picasso"

STEVE JOBS

A DROPOUT-TURNED-VISIONARY TAUGHT THE WORLD TO THINK DIFFERENTLY ABOUT MUSIC, MOVIES, WORK AND LIFE

"Put a dent in the universe," he used to say, exhorting his colleagues to excel.

The visionary Zen Master of Tech—who brightened the world by bringing to life the Apple computer and the Mac, the iPod, the iPhone and the iPad and oh, yes, Buzz Lightyear and the digital animation gang from Pixar—came as close as any earthbound geek can to leaving his mark (okay, Mac mouse print) in the cosmos. "In a world littered with dull objects, he brought the beauty of clean lines and clear thought," U2's Bono said of his friend. "He changed music. He changed film. He changed the personal computer and turned telephony on its head while he was at it."

He did it with a quirky, demanding personality that inspired both devotion and exasperation. "He was like the parent you would keep doing stuff for, but it was never going to be enough," said one former Apple exec. Although "he waited in line in the cafeteria along with everybody else, he wasn't a particularly approachable person." Stories of Jobs's obsession with even the smallest detail, and of his publicly browbeating subordinates whose work disappointed him, were legion. But the results, of course, were historic. A kind interpretation of the Jobs Way? "In a symphony orchestra, they have sheet music and the orchestra leader sticks to that," said former Apple senior VP Jay Elliot. "But a jazz band leader is different. It's 'Okay, here's a key and here's a beat. All the open areas you fill in.' Steve was that kind of artist."

Born to grad school students, who put him up for adoption, and raised in a blue-collar Bay Area family, Jobs turned presumed wrong turns— he dropped both LSD and out of college in his early 20s; fathered a child out of wedlock and managed to get himself fired from Apple nine years after he founded it—into a career path of unparalleled success. He died at 56, after an eight-year battle with pancreatic cancer.

Said architect Michael Graves: "He's been compared to Einstein and Edison, but he really should be compared to Picasso. There are people who change the art form they are working in."

GIANNI VERSACE

SAID ONE ADMIRER: "HE MADE CLOTHES FOR WOMEN WHO WANT TO WALK INTO A ROOM AND HAVE PEOPLE SAY, 'WOW!'"

Sixteen years later, it still makes no sense. Gianni Versace, supernova of Italian design, stopped at a café, bought a handful of magazines and strolled back to Casa Casuarina, the elegant palazzo he called home in Miami. As he opened the front gate, a young man stepped up and shot him twice in the head.

The killer's identity proved almost as shocking as the crime: Andrew Cunanan, 27, was 2½ months into a bizarre killing spree that had landed him on the FBI's 10 Most Wanted list. A high-priced prostitute who lived off wealthy older men, Cunanan had murdered David Madson, 33, an architect, and Jeffrey Trail, 28, in Minnesota; Chicago millionaire Lee Miglin, 72; and cemetery caretaker William Reese, 45, in New Jersey. Police found Reese's stolen red pickup truck blocks from Versace's villa; eight days later, as they closed in on a Miami houseboat where Cunanan was thought to be hiding, he shot himself in the head.

Although there was some evidence that victim and killer may have met at some time in their lives, Versace, 50, most likely died because he represented everything Cunanan desperately wanted. "I think he looked at Versace as a symbolic victim," said former FBI agent Robert K. Ressler. "Versace represented and stood for power, wealth, fame, celebrity, flamboyant lifestyle—everything Cunanan worshipped and aspired to."

Versace built that life from nothing. The son of a seamstress and an appliance salesman from dirt-poor Reggio di Calabria in southern Italy, he designed his first gown at 9—a one-shouldered, black-velvet affair—and launched himself toward the stratosphere with a collection under his own name in 1978. Mixing elegance and shock value—he once described himself as "half royalty and half rock and roll"—he became a favorite of celebrities from Princess Di to Madonna and amassed a fortune estimated at $800 million. Though mindful of money's limitations—"I prefer a happy vulgar person to an unhappy chic person," he once said—he delighted in those things that money *could* buy. "It was lavish beyond belief," fashion journalist Michael Gross recalled of a visit to Versace's 17th-century Milan palazzo. "A room full of antique globes, every single one of them beautiful objects. Waiters everywhere, champagne flowing and pieces of furniture so deep your legs didn't reach the edge if you leaned back. He was playing out a dream of wealth beyond measure.... It's like the Sun King. He reflected light on to those around him, and they in turn reflected back upon him."

"I just want to live like everyone else,
'cause that's what counts in high school"

1971–1990

RYAN WHITE

INFECTED WITH HIV, HE TAUGHT AMERICA A LESSON IN COMPASSION

He was just a kid from Kokomo, pretty much like any other, until a blood transfusion for his hemophilia at age 12 infected him with HIV. When Ryan White was diagnosed with AIDS in '84, some kids shunned him, and he was banned from middle school. He and his family successfully sued to have him readmitted, but the conflict had unleashed a wave of vitriol in the quiet Indiana town: Kids scribbled obscenities on his school locker, callers on radio talk shows labeled him "faggot," "homo" and "queer," and somebody slashed the tires on his family's car. After a bullet was fired through the Whites' living room window, the family decided to leave the town.

The heartbreaking story of Ryan White's persecution thrust him into the national spotlight; his guileless charm, and the power of his story, kept him there. Invited to speak on TV and in schools, he won over audiences with simple, honest answers to difficult questions. Do you cry, one woman asked? "I cry a lot for emotional reasons," he said. "Not for pain." Are you afraid of dying? "No. If I were worried about dying, I'd die. I'm not afraid, I'm just not ready yet. I want to go to Indiana University." What was it like in Kokomo? "[Kids would] run from me. Maybe I would have been afraid of AIDS too, but I wouldn't have been mean about it." Asked by a minister how his Christian faith had helped him cope, Ryan replied, "I've learned that God doesn't punish people. I've learned that God doesn't dislike homosexuals, like a lot of Christians think. AIDS isn't their fault, just like it isn't my fault."

Early on in the scourge of AIDS, Ryan White caused many Americans to reconsider what they had thought about the disease. "You're gonna do good for everybody who is sick," his mother, Jeanne, whispered to him as he lay dying. "It's a shame it has to be you." A few hours later she whispered, "Just let go, Ryan. It's time. Goodbye, buddy, goodbye, my pumpkin. I want to kiss you goodbye one more time." Moments later, the green dial on the heart monitor clicked off.

JONBENET RAMSEY

A CHILD MURDERED AT CHRISTMASTIME.
FAR FROM OPEN AND SHUT,
THE CASE MAY STAY OPEN . . . FOREVER

As Patsy Ramsey later told authorities, she walked downstairs to make coffee on Dec. 26, 1996, and discovered a note, neatly hand-printed, claiming that her daughter JonBenét, 6, had been kidnapped and demanding a ransom of $118,000. Patsy said she ran to her daughter's room, found the bed empty, let out a scream and phoned police. Hours later, as the family and investigators waited for a call from the alleged kidnappers, Patsy's husband, John, began a search of the Boulder, Colo., home and found JonBenét, her mouth taped shut and a cord around her neck, dead in a basement room.

John and Patsy drew suspicion when both hired criminal lawyers and initially refused to be formally interviewed by police. Neither was ever charged with a crime, and Patsy died of cancer at 49 in 2006. Two months later, the arrest of a suspect, John Mark Karr, in Thailand became an embarrassment when his confession was nullified by DNA evidence. In 2008 the Ramseys were exonerated by the Boulder District Attorney. The case remains one of America's greatest unsolved mysteries.

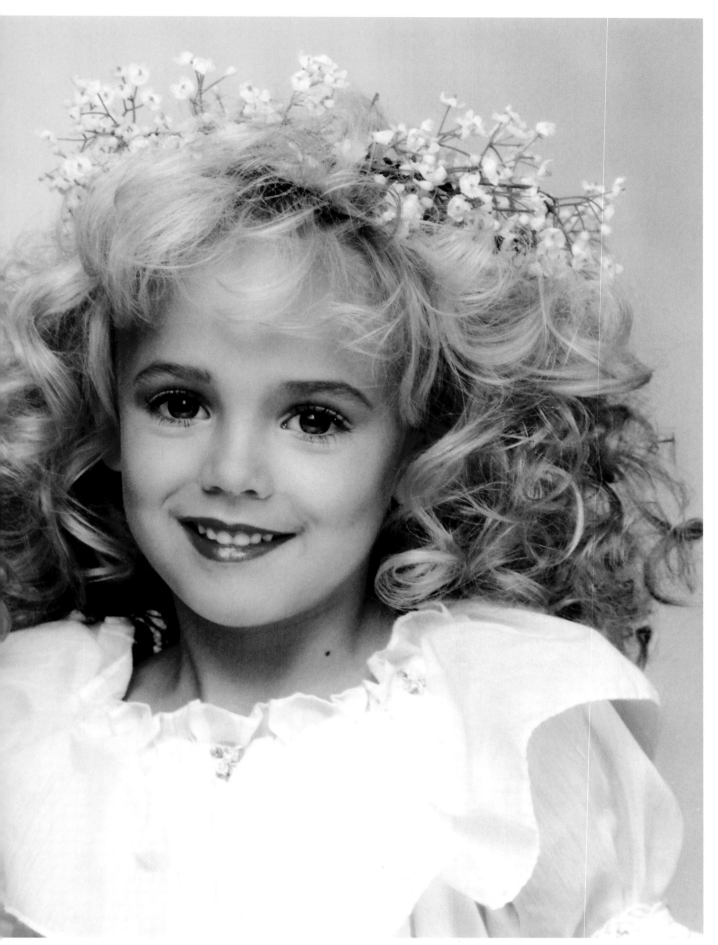

1967–1995

SERGEI GRINKOV

THE BEST PAIRS SKATERS IN THE WORLD, G&G WERE, ABOVE ALL, A LOVE STORY

A pair of mismatched children thrown together by the Soviet regime and told to skate for the good of the state, Sergei Grinkov and Ekaterina Gordeeva grew up to become the most celebrated pairs skaters ever—and, while winning numerous world championships and two Olympic gold medals, to fall madly in love. Said former skating champion Dick Button: "God gave them so much—Sergei was the perfect pairs skater, perfect husband, perfect father [to their daughter Daria]. It was as though God had to pull something back."

On Nov. 20, 1995, while training with Gordeeva, 24, in Lake Placid, N.Y., for a *Stars on Ice* tour, Grinkov, 28, complained of dizziness. The couple had just completed a lift, and Gordeeva helped him sit on the ice. Then he fell backward, unconscious.

Katia screamed. Paramedics responded in minutes, and doctors at the Adirondack Medical Center worked on Grinkov for more than an hour, to no avail. "He was dead the moment he hit the ice—he felt no pain," said Dr. Josh Schwartzberg. An autopsy showed Grinkov's heart was enlarged, probably from high blood pressure, and one coronary artery was virtually closed. He had suffered a "silent" heart attack within the previous 24 hours, one that might have caused no pain but may have started a fatal heart rhythm.

Gordeeva's grief "was so powerful, it was heart-wrenching," said Schwartzberg. "She wanted to go in and be with him. I was afraid to leave her alone, but she started speaking in Russian to him in a very gentle, soft and affectionate way. I was very moved by how she caressed and kissed him." Just before she left, she unlaced her husband's skates and gently removed them from his feet. "She was talking to Sergei," a friend, skater Elena Bechke, said later, "telling him, 'Everything will be okay; I will always love you.' I think Katia will be okay too. She will live for Sergei. There will not be another partner for her. They'd won everything together. They were everything together."

Gordeeva continues to perform, but never competed again in pairs. In 2002 she married fellow skater Ilia Kulik.

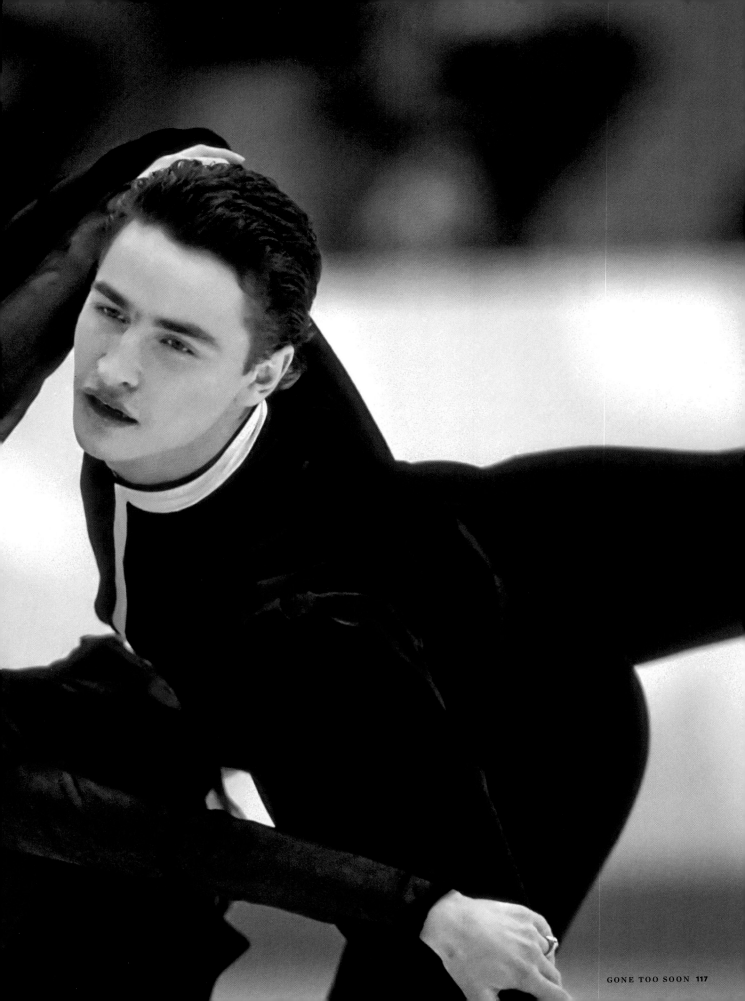

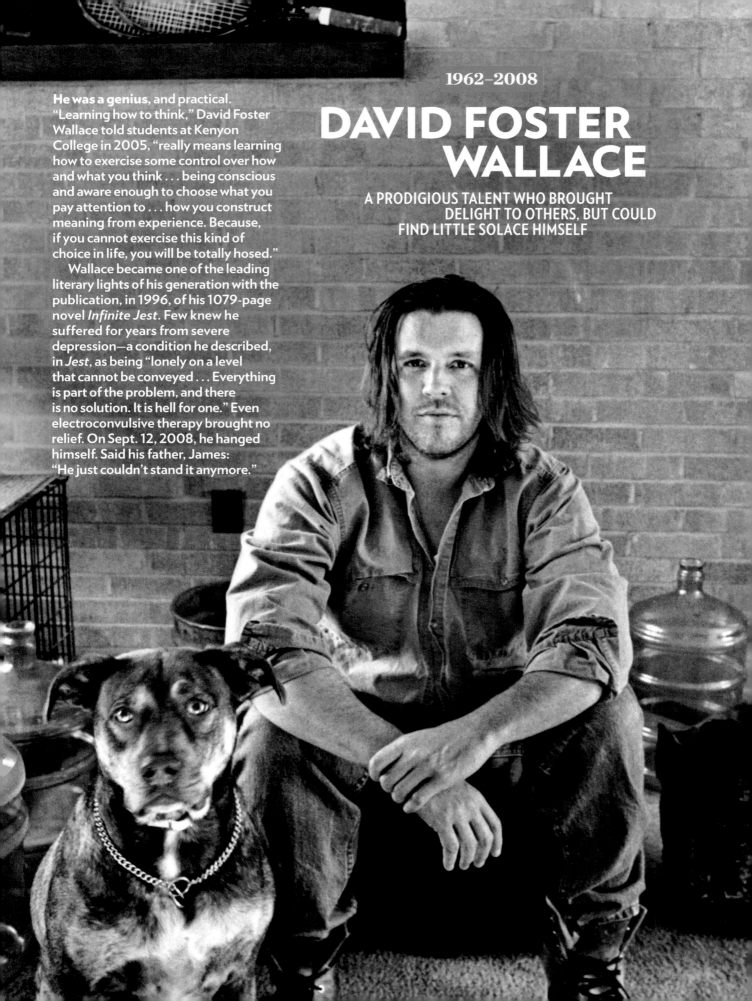

1962–2008

DAVID FOSTER WALLACE

A PRODIGIOUS TALENT WHO BROUGHT DELIGHT TO OTHERS, BUT COULD FIND LITTLE SOLACE HIMSELF

He was a genius, and practical. "Learning how to think," David Foster Wallace told students at Kenyon College in 2005, "really means learning how to exercise some control over how and what you think . . . being conscious and aware enough to choose what you pay attention to . . . how you construct meaning from experience. Because, if you cannot exercise this kind of choice in life, you will be totally hosed."

Wallace became one of the leading literary lights of his generation with the publication, in 1996, of his 1079-page novel *Infinite Jest*. Few knew he suffered for years from severe depression—a condition he described, in *Jest*, as being "lonely on a level that cannot be conveyed . . . Everything is part of the problem, and there is no solution. It is hell for one." Even electroconvulsive therapy brought no relief. On Sept. 12, 2008, he hanged himself. Said his father, James: "He just couldn't stand it anymore."

TIM RUSSERT

BEHIND THE NEWSHOUND FACADE, A MAN WHO THRIVED ON FAMILY, FAITH AND FRIENDS

The family had been on vacation in Rome, but NBC newsman Tim Russert had to leave early to return to Washington to host *Meet the Press*. He hated saying goodbye; so did his wife, journalist Maureen Orth. "I said, 'I want to give you a hug. I don't know if I'll ever see you again,'" she recalled later. "I don't know why I said that to him. I just had a feeling."

Tragically, she was right to worry. The next day Russert, 58, collapsed at work and died of a heart attack. The shock and sadness among friends and colleagues—and thousands of fans of *Big Russ and Me*, his moving account of his Depression-era father raising a baby-boomer son—was palpable. "Family and faith were the foundations of his life," wrote his friend Tom Brokaw, who called Russert "America's premier political journalist." At Russert's memorial service, Brokaw spoke about the essence of his friend's everyman appeal: "[He] awoke every morning as if he had just won the lottery the day before. He was determined to take full advantage of his good fortune that he couldn't quite believe and share it with everyone around him."

What mattered most to Russert was family: Orth and their beloved son Luke, who was 22 at the time of his father's death. "Before Luke was born," said a friend, "Tim made a promise with God that if his child was born healthy, he would attend Mass every week." He kept his promise, and became extremely close to his son. "My father would rather drink a few beers with me and my buddies in the backyard," said Luke, "than attend some A-list party."

Lack of pretension was a Russert trademark. Says Orth: "I'd always say to him, 'Why don't you buy a nice suit?' and he'd say, 'That's not me.' Lands End and L.L. Bean have lost a good customer."

"Tim was a happy man," she added. "He realized all of his dreams."

RANDY PAUSCH

STICKEN WITH CANCER, A PROFESSOR OFFERS A SURPRISING GIFT

A star in his academic field, Carnegie Mellon computer science professor Randy Pausch, 47, catapulted to fame after he delivered the university's traditional Last Lecture in September 2007. Intended to showcase a professor's personal philosophy, the lecture in Pausch's case really would be one of his last: Diagnosed with pancreatic cancer, he'd recently been told he had, at best, six months to live. Filled with the kind of simple yet sage advice Pausch had always given his students—never give up on your dreams; find the best in others; have fun—the lecture went viral, drawing 10 million new listeners. *The Last Lecture*, a follow-up book that expanded on his thoughts, became a global phenomenon and was published in 30 languages. Pausch, married and a father of three young children, died July 25, 2008. "Randy," said his sister Tamara Mason, "had magic."

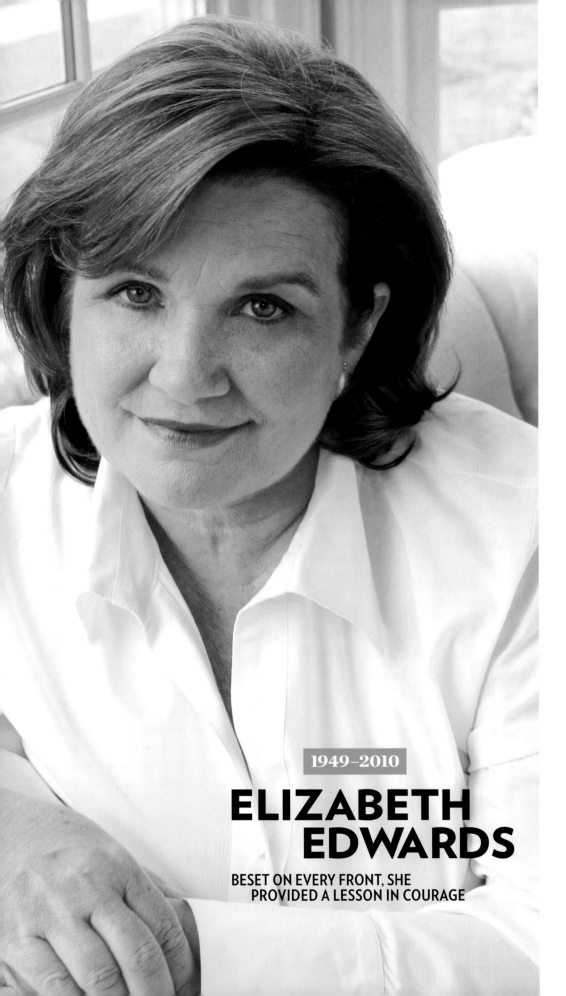

1949–2010

ELIZABETH EDWARDS

BESET ON EVERY FRONT, SHE PROVIDED A LESSON IN COURAGE

She came into public view as a political wife; she will be remembered as her own woman: a loving mom, strong in adversity, graceful even as fate dealt, it seemed, from the bottom of the deck.

As her husband, John, a shiny, camera-ready North Carolina senator, campaigned for the Democratic presidential nomination in 2008, Elizabeth learned the cancer she had battled three years before had returned. Nonetheless, she encouraged her husband to continue his quest.

Then came rumors that John had been having an affair with campaign videographer Rielle Hunter. At first he denied it—then admitted it was true and ended his campaign.

Hunter had given birth to a child; John at first denied he was the father—only to admit, in 2010, the infant was his.

Through it all, Elizabeth absorbed the blows and focused on one question: What could she do to ensure the happiness of her children, Cate, Jack and Emma Claire? In the end, she decided that included keeping the lines of communication open with John, who would one day be their only parent.

After fighting cancer for six years, Elizabeth died at home, surrounded by family, including John. Said Cate: "She taught me the meaning of grace."

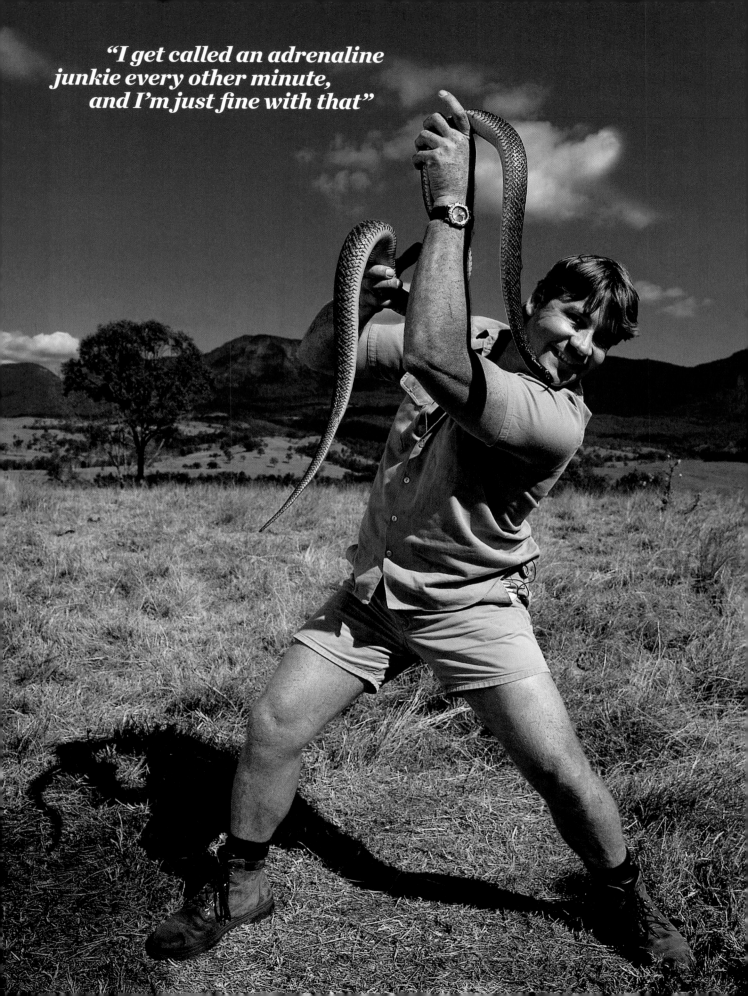

"*I get called an adrenaline junkie every other minute, and I'm just fine with that*"

STEVE IRWIN

FOR TV'S CROC HUNTER, DEATH CAME OUT OF THE BLUE

Anchored off Australia's Great Barrier Reef in 2006, Crocodile Hunter Steve Irwin decided to film a segment for his daughter Bindi's upcoming wildlife show on the Discovery Kids channel. "He was in such a good frame of mind," said longtime friend John Stainton. "We sat together in the early hours, 5 a.m., 6 a.m., having a cup of tea, just talking about how good life was."

Irwin, 44, slipped into the water with his cameraman to film a school of stingrays, docile creatures who usually tolerate visitors. Then it happened. As Irwin snorkeled above a bull ray, it stopped, then whipped its razor-sharp tail directly up toward Irwin and plunged the barb deep into his chest, piercing his heart.

Irwin pulled the barb out himself, and crewmen quickly hauled him aboard his boat. But there was no way to stop the bleeding. "He pulled the barb out," said Stainton, "and the next minute he's gone. That was it."

Irwin's Animal Planet adventure shows, including *The Crocodile Hunter* and *Croc Files,* had made him a familiar figure to kids and their parents around the world; in Australia, where he was something of a national mascot, the prime minister offered to hold a state funeral. Said actor Russell Crowe, a friend: "He touched my heart. I believed in him."

Slowly recovering from the tragedy, Irwin's American-born wife, Terri, took up the job of continuing the family's Australia Zoo, on the country's Queensland coast; daughter Bindi won a Daytime Emmy for her show, *Bindi the Jungle Girl,* which ran for a year beginning in 2007. She continues to act in TV and movies and was recently filming *Return to Nim's Island.*

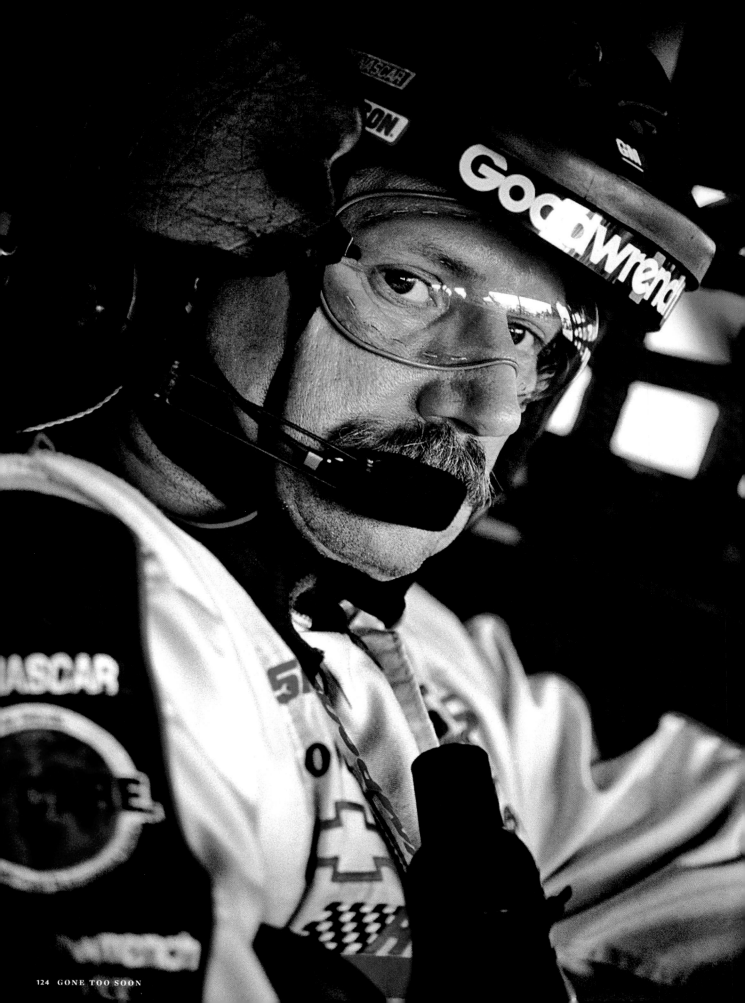

DALE EARNHARDT

BORN TO RUN FLAT OUT, THE INTIMIDATOR BECAME NASCAR NOBILITY

He roared through life at his own pace, somewhere around 200 mph. But there was more to Dale Earnhardt's appeal than speed or the way he careened around racetracks with seeming abandon, menacing other drivers with bumper-to-bumper aggressiveness. In many ways he was the modern incarnation of the rural southern male of yore: tough, skeptical, independent, with no back-down in him. "I want to give more than 100 percent every race, and if that's aggressive, then I reckon I am," Earnhardt once said. "It's not a sport for the faint of heart."

His father, Ralph, had been a NASCAR champion. It became clear early that Dale, too, longed to get his hands oily. "I tried ninth grade twice and quit," he said. "Couldn't hang, man, couldn't hang." Dale's decision to work odd jobs while racing on dirt led to some estrangement between father and son. "He was against me dropping out of school to go racing," Dale told the *L.A. Times,* "but he was the biggest influence on my life."

Earnhardt, known as the Intimidator, became the Michael Jordan of his sport, a multimillionaire with an army of ardent fans. "He represented everything you kind of look up to," said one. Said Becky Duckworth—millions

of Earnhardt's fans were female—"Besides my husband, Dale Earnhardt is the only man I've ever loved." He acquired all the toys a man could want—Earnhardt owned a jet, a helicopter and a 76-ft. Hatteras, and his mechanics worked in a facility so large they called it the "garage-Mahal"—but, as a kid who grew up in the textile mill town of Kannapolis, N.C., he never lost touch with his roots. When North Carolina farmers faced ruin after a flood, Earnhardt, racing writer Ed Hinton recalled, told them, "Just y'all have those damn tractors ready to roll when that seed gets here." "Later," said Hinton, "I learn that the seed he sends them, at his expense, is measured in tons."

Earnhardt, 49, died doing what he loved. On Feb. 18, 2001, seconds from the finish line at the Daytona Speedway, he and Sterling Marlin, battling for third place, bumped cars; Earnhardt spun sideways, was hit by another car and then slammed head-on into a concrete wall. He died instantly from head trauma. Later that year NASCAR began requiring that drivers wear head-and-neck support devices during races.

"I've heard people say we're going too fast," he once said. "Maybe we do, maybe we don't. [But] do you want to race or don't you?"

KEIKO

THE DEATH OF THE *FREE WILLY* WHALE ENDED A SAGA THAT CAPTURED THE WORLD'S IMAGINATION

Although he died in Norway, Keiko, the killer whale who starred in three *Free Willy* movies, may have suffered from Stockholm syndrome: the tendency of internees, over time, to identify with their captors.

Captured off Iceland in 1979, Keiko became a marine park attraction until the phenomenal success of the *Free Willy* movies sparked an international movement to release him into the wild. More than $20 million was spent training Keiko to survive in the open ocean.

But after his release in Iceland in 2002, Keiko swam 870 miles to a quiet Norwegian fjord, apparently because he liked being around people. He was deluged by visitors until local officials forbade close contact.

Keiko settled in nearby Taknes fjord until he died, from a sudden case of pneumonia, on Dec. 12, 2003. To avoid a media circus, he was buried at night, in a field near the shore, with only a handful of his caretakers in attendance.

Editor Cutler Durkee
Design Director Andrea Dunham
Photo Director Chris Dougherty
Photo Editor C. Tiffany Lee-Ramos
Art Director Heather Haggerty
Reporter Ellen Shapiro
Copy Editor Will Becker

Scanners Brien Foy, Salvador Lopez, Stephen Pabarue
Editorial Operations Director Richard Prue
Imaging Manager Rob Roszkowski
Imaging Production Managers Romeo Cifelli, Jeffrey Ingledue

Special thanks: Céline Wojtala, David Barbee, Jane Bealer, Patricia Clark, Margery Frohlinger, Suzy Im, Ean Sheehy, Patrick Yang

TIME HOME ENTERTAINMENT
Publisher Jim Childs
Vice President, Brand & Digital Strategy Steven Sandonato
Executive Director, Marketing Services Carol Pittard
Executive Director, Retail & Special Sales Tom Mifsud
Executive Publishing Director Joy Butts
Director, Bookazine Development & Marketing Laura Adam
Finance Director Glenn Buonocore
Associate Publishing Director Megan Pearlman
Assistant General Counsel Helen Wan
Assistant Director, Special Sales Ilene Schreiner
Design & Prepress Manager Anne-Michelle Gallero
Brand Manager Michela Wilde
Associate Prepress Manager Alex Voznesenskiy
Associate Brand Manager Isata Yansaneh
Assistant Production Operations Manager Amy Mangus
Editorial Director Stephen Koepp

Special thanks:
Katherine Barnet, Jeremy Biloon, Susan Chodakiewicz, Rose Cirrincione, Jacqueline Fitzgerald, Christine Font, Jenna Goldberg, Hillary Hirsch, David Kahn, Kimberly Marshall, Amy Migliaccio, Nina Mistry, Dave Rozzelle, Ricardo Santiago, Adriana Tierno, Vanessa Wu

ISBN 10: 1-61893-092-3
ISBN 13: 978-1-61893-092-7
Library of Congress Control Number: 2013936687
Copyright © 2013 Time Home Entertainment Inc.

Published by People Books, an imprint of Time Home Entertainment Inc., 135 West 50th Street, New York, N.Y. 10020.

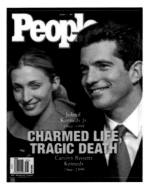

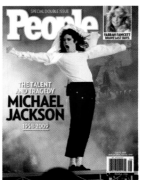

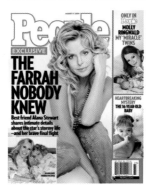

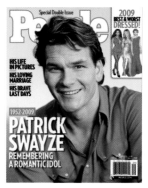

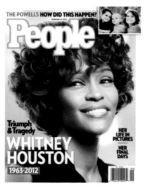

FRONT COVER
Clockwise from top left: Tim Rooke/Rex USA; Lance Staedler/Corbis Outline; Jonathan Exley/Contour by Getty Images; Douglas Kirkland/Corbis; Brownie Harris/Corbis; Polaris

CONTENTS
Clockwise from bottom right: Phil Loftus/Capital Pictures/Retna; J Lundgren/Reportagebild/Ipol/Globe; James D. Morgan/Rex USA; Dick Zimmerman/Shooting Star; Howell Conant/Bob Adelman Books; Nancy R. Schiff/Getty Images; Hulton Archive/Getty Images; Shooting Star; Lynn Goldsmith/Corbis; Mike Segar/Reuters

UNFORGETTABLE
6-7 Kim Knott/Camera Press/Redux; **8-9** Alpha Photo Press Agency; **10-11** (from left) Newspix Int'l; Reuters; **13** Robert Duetsch/USA Today; **14** Paul Adao/NY News Service; **15** (from top) Corbis Bettmann; Olympia/Sipa; **16-17** Greg Allen/Retna; **18** (clockwise from left) Rex USA; Kevin Mazur/Wireimage; Giles Petard/Dalle/Landov; Courtesy Universal; **19** Fin Costello/Redferns/Getty Images; **20-21** John Kelly/Camera Press/Redux; **22** (from top) LFI; Sunshine Int'l/Sipa; **23** Allan Tannenbaum/Polaris; **24-25** Howell Conant/Bob Adelman Books; **26** AFP/Getty Images; **27** Snowdon/Camera Press/Redux; **28-29** Roger Marshutz/MPTV; **30** (top row, from left) Frank Carroll/Sygma/Corbis; Everett; Frank Driggs Collection/Getty Images; (middle row, from left) Michael Ochs Archives/Getty Images; Bettmann/Corbis; Michael Ochs Archives/Getty Images; (bottom row, from left) Michael Ochs Archives/Getty Images(2); Charles Trainor/Time & Life Pictures/Getty Images; **31** Michael Ochs Archives/Getty Images

ENTERTAINERS
33 Bruce McBroom/MPTV; **34-35** Douglas Kirkland/Corbis Outline; **37** Lance Staedler/Corbis Outline; **38-39** Patrick Harbron; **40-41** Ben Watts/Corbis Outline; **42** Lance Staedler/Corbis Outline; **44** Benno Friedman/Corbis Outline; **46-47** Owen Franken/Corbis; **48** (clockwise from top left) NBCU Photobank/Getty Images; Al Levine/NBCU Photobank/Getty Images; Fred Hermansky/NBCU Photobank/Getty Images; SMP/Globe; **50-51** Dick Zimmerman/

Shooting Star; **52-53** Luke Wynne/Liaison Agency/Zuma; **54** Art Streiber/Trunk Archive; **55** MPTV; **56-57** Carolyn Schultz; **58-59** Timothy Greenfield-Sanders/Corbis Outline; **60** Neal Preston/Corbis Outline; **61** Daniela Federici/Corbis Outline; **62** Wenn; **63** Davis Factor/Art Mix; **64-65** Chris Buck/August(3); **66-67** Mimi Cotter; **68-69** Everett; **70-71** Robert Trachtenberg/Trunk Archive

MUSICIANS
73 Firooz Zahedi/Trunk Archive; **74-75** Dirck Halstead/TLP/Getty Images; **76** (clockwise from top) Sam Emerson/Polaris; Cesar Vera/Contour by Getty Images; Joseph Gotfriedy/Broadimage; **77** Richard Corman/Corbis Outline; **78** Sung Park/The Austin American-Statesman/Polaris; **81** Martyn Goodacre/Retna; **82** Frank Micelotta/Getty Images; **83** Marcel Noecker/DPA/Landov; **84** Lynn McAfee/Globe; **85** Shepard Sherbell/Corbis Saba; **86-87** Denis O'Regan/Idols/Photoshot; **89** Ross Kirton/Eyevine/Redux; **90** Danny Clinch/Contour by Getty Images; **91** Barron Claiborne/Corbis Outline; **93** Lynn Goldsmith/Corbis; **95** Kwaku Alston/Corbis Outline; **96-97** Deborah Feingold/Corbis; **98** Catherine Ledner/Corbis Outline; **99** Michael Ochs Archives/Getty Images; **101** Deborah Feingold/Corbis; **102** Robert Knight Archive/Redferns/Getty Images; **103** David Berkwitz/Polaris; **105** Herb Greene

NEWSMAKERS
107 Norman Seeff; **109** Mark Richards; **111** Alexis-Rodriguez-Duarte/Corbis Outline; **112-113** Kim Komenich//Time Life Pictures/Getty Images; **114-115** Randy Simons/Polaris; **116-117** Bill Franks/Sports Illustrated; **118** Marion Ettlinger/Corbis Outline; **119** Alex Wong/Meet The Press/Getty Images; **120** Pam Panchak/Post-Gazette/AP; **121** Deborah Feingold/Corbis Outline; **122** Greg Barrett; **124** Nigel Kinrade/Autostock; **127** Sipa

BACK COVER
Clockwise from top left: Norman Seeff; Charles W. Bush/Shooting Star; Photofest; Ben Watts/Corbis Outline; Timothy Greenfield-Sanders/Corbis Outline; Dick Zimmerman/Shooting Star; Denny Renshaw/Corbis Outline